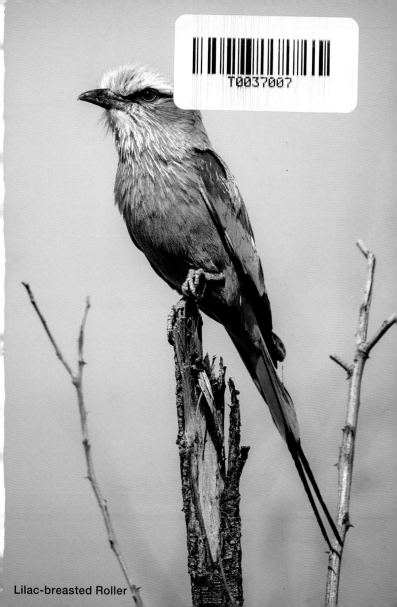

Lilac-breasted Roller

# Kruger Birds

Philip van den Berg

**HPH Publishing**

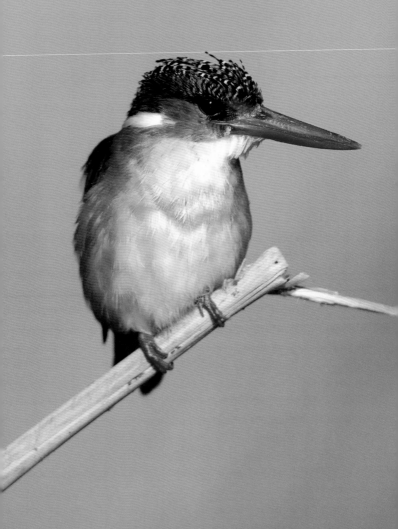

Malachite Kingfisher

# CONTENTS

INTRODUCTION                        6

THE BIG SIX                         8

FIRST SECTION

    Birds of prey                   10

    Birds at the water              52

    Ground-living birds            110

    Birds in trees                 138

SECOND SECTION

    Thumbnails                     232

INDEX                              288

# INTRODUCTION

Southern Africa boasts an incredible diversity of climates, biomes, vegetation types, and habitats, which contribute to an exceptional variety of bird species. In the Greater Kruger region, situated in the savanna biome, over half of all bird species in southern Africa can be found. Birdwatching has been gaining popularity, and Kruger Birds, a comprehensive guidebook covering 447 Greater Kruger bird species, can make it easier for you to become familiar with the birds typically seen on game drives in the area.

The **first section** of the guidebook's main body is organized based on shared habitats, with unconventional groupings that take into account other factors when necessary. While the groupings are not mutually exclusive, they offer a useful way of making sense of the wide range of bird species that can be overwhelming. The first group is about birds of prey which includes diurnal and nocturnal raptors. The second grouping includes birds associated with a water habitat. Ground-living birds are next. A few grassland birds are included under this category because many grassland birds are difficult to identify. The vast majority of birds in the Greater Kruger region inhabit bushes and trees and are more challenging to identify. Some tree-living birds forage on the ground but return to trees to breed and roost. Others feed on leaves, flowers, fruits, and seeds. Some birds use trees as perches to hunt insects and invertebrates on the ground, while others find food in the bark and on other surfaces.

The **second section** is a convenient 'quick find' resource that arranges species based on their families, with smaller pictures and page numbers referring to the first section of the book. Sightings can be recorded in tick boxes.

Overall, Kruger Birds is an excellent resource for bird enthusiasts seeking to learn more about the diverse birdlife of the Greater Kruger region.

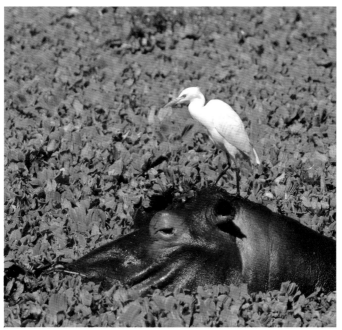

**Western Cattle Egret**

# A few tips for birders:

- Approach birds with the minimum disturbance and sit quietly, watching with your binoculars.
- Avoid noise and sudden movements.
- Birds are most active between dawn and 11:00 and again from 16:00 until nightfall.
- Birds are colour-conscious, and their vision is up to two and a half times more powerful than ours.

# THE BIG SIX

Avid birders and conservationists often group the most sought-after birds in Kruger as the Big Six. All of them are magnificent in appearance and in behaviour. Kruger and other conservation areas are a safe haven but even here their survival is affected by human activities in areas surrounding the park.

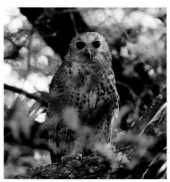

Pel's Fishing Owl

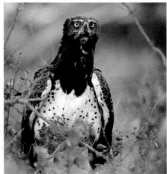

Martial Eagle

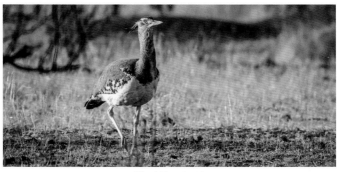

Kori Bustard

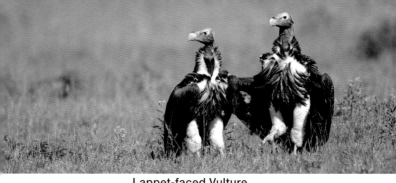

Lappet-faced Vulture

Southern Ground Hornbill

Saddle-billed Stork

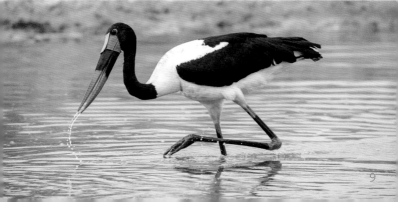

# BIRDS OF PREY

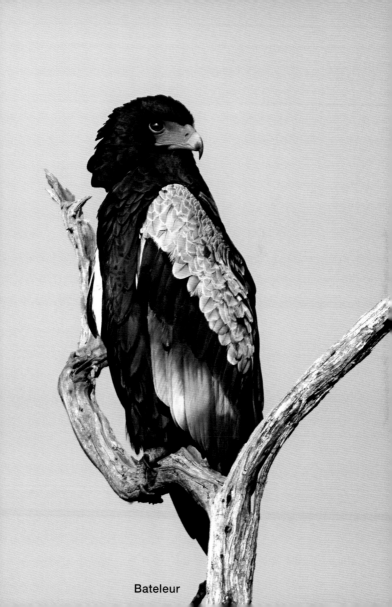

Bateleur

# BIRDS OF PREY

The birds of prey are the bigger flesh-eating birds. They include the diurnal and nocturnal raptors and the scavenging vultures. Raptors are the butchers of the bird world and use talons to catch and kill their prey. All have strongly hooked bills and powerful feet with sharp talons, but the size, appearance and behaviour vary in the different species and this enables each species to fill a special niche and thus minimise competition. Vultures are the avian undertakers and seldom kill their own prey.

# The giants

Eagles are the largest of the raptors – all are strongly built with exceptionally powerful talons.

**Martial Eagles** are aggressive and versatile hunters that hunt from great heights while soaring. Look for the dark breast and spotted white underparts to identify them. They prey on a variety of small to large mammals, birds and reptiles. These could be small antelope, hyraxes, hares, birds up to the size of a Kori Bustard, and reptiles such as monitor lizards.

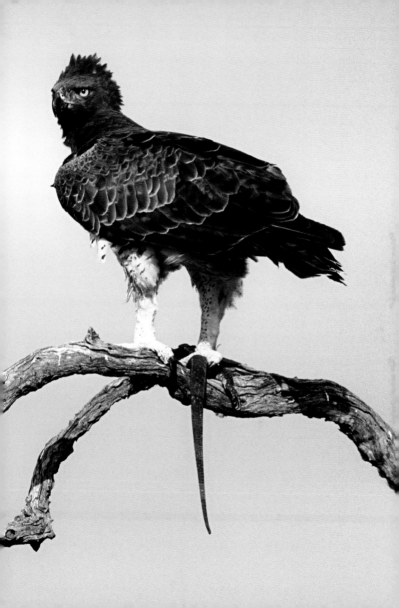

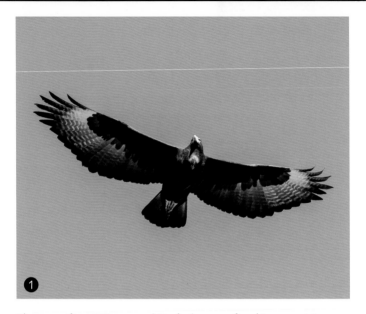

The magnificent **Verreauxs' Eagles**[1] are confined to mountainous areas with cliffs where they nest on rock ledges. They are the most prey-specific of all large raptors as the greater part of their diet consists of rock hyraxes. However, they do take other mammals and game birds.

**Crowned Eagles**[2] have broad, short wings and long tails for manoeauvrability when pursuing prey in dense trees. It is an extremely powerful raptor with exceptionally large talons, enabling it to kill prey up to the size of a young bushbuck. It is also a successful hunter of monkeys. Large prey is dismembered and pieces are cached in trees.

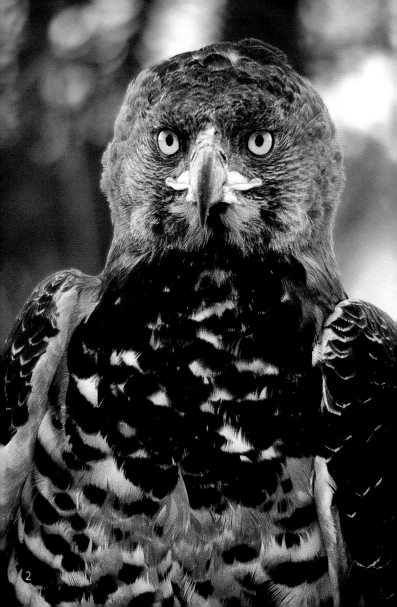

**Wahlberg's Eagles**[1] are intra-African breeding migrants that usually arrive in August in southern Africa and commence breeding in September. Although often overlooked, they are the most common small eagles during summer. There is quite a colour variation between different individuals but they all have dark brown irises, black bills and yellow feet and ceres (fleshy coverings at the base of the upper beak). They prey on small mammals, birds, reptiles and insects and even prey as big as guineafowls and hares are caught.

**African Hawk Eagles**[2] are rapacious and dashing raptors that mainly prey on game birds but they take mammals and reptiles. They hunt from a perch or flying low over the ground. They frequently ambush prey at waterholes which is sometimes heavier than the birds themselves.

**Tawny Eagles**[3] vary in colour from dark brown to pale buff. They are typical savanna raptors that normally occur in pairs. They are opportunistic and take a variety of prey, ranging from medium-sized mammals to insects. They scavenge and are often the first to arrive at a carcass. A fair percentage of their prey is obtained through pirating, and fledglings are also taken from open nests.

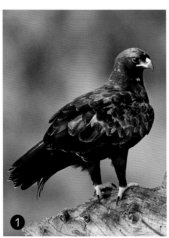

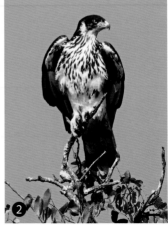

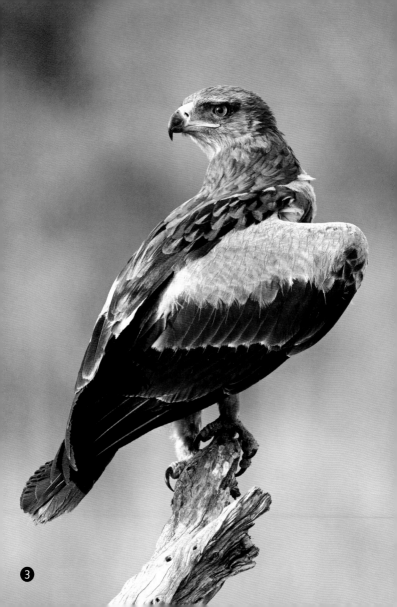

The cry of the **African Fish Eagle** is often referred to as the 'call of Africa'. These iconic birds prefer water habitats, usually with big trees. They hunt from a perch and mainly take fish. They also pirate birds such as herons and storks, and sometimes catch waterbirds and their chicks.

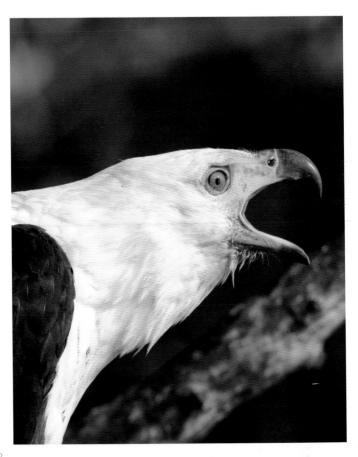

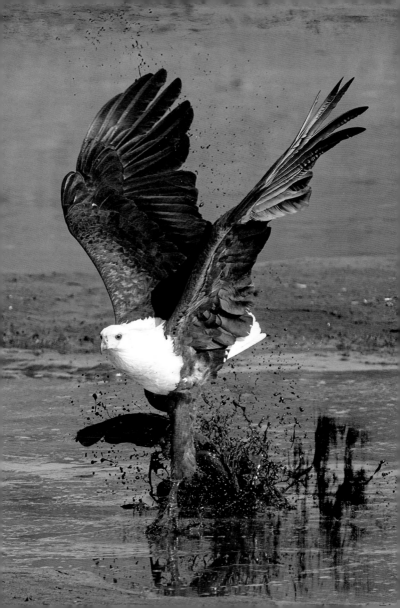

# Acrobat of the sky

The red face, legs and feet, distinctive plumage and the characteristic flight pattern can only be that of the master of soaring, the Bateleur.

A flying **Bateleur** rocking from side to side is a magnificent sight of the African bush. In this way they cover immense distances looking for food. They are scavengers to a large extent but do sometimes hunt birds and smaller prey.

**Juvenile**

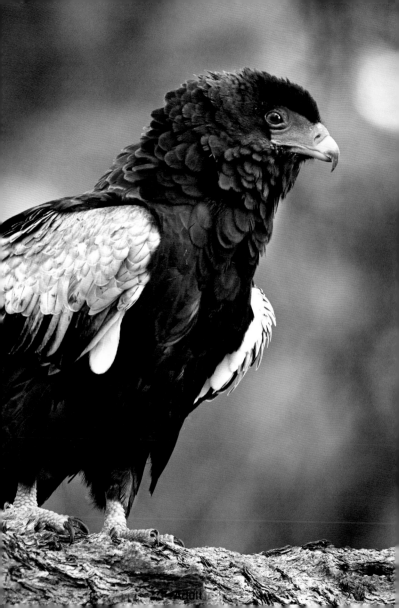

# The snake killers

Snake Eagles are specialist snake killers and they prey almost entirely on these reptiles, swallowing them whole. When nesting, they half ingest a snake and the nestlings pull it out when the parent arrives at the nest. They have long, heavily scaled legs and short toes, and large yellow eyes.

**Black-chested Snake Eagles**[1] have black heads and breasts and white underparts. They occur in lightly wooded and also in desert areas. They hunt while soaring, and drop down on their prey.

   **Brown Snake Eagles**[2] are uniformly brown eagles with light legs and large, yellow eyes. They frequently hunt from a perch, killing and swallowing prey on the ground.

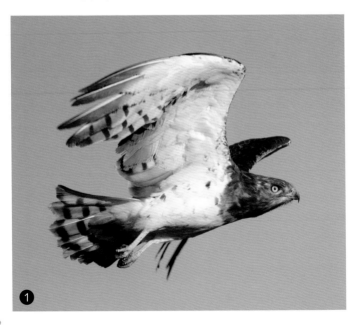

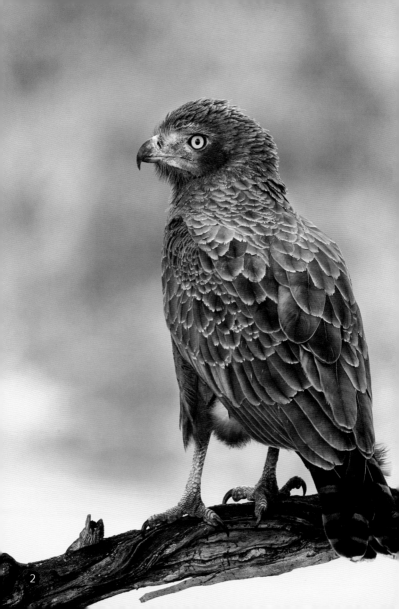

# The trapeze artist

In nature there is often a species that has developed special features to obtain food others cannot utilise. One such species is the African Harrier-hawk.

**African Harrier-Hawks** are unusual in both appearance and behaviour. They have yellow faces without plumage which turn red when they are excited, and their ankles seem to be double-jointed. They forage by hanging upside down by one foot while inserting the other flexible foot into hollows, cracks or birds' nests to get hold of prey. They are great robbers of weavers' nests.

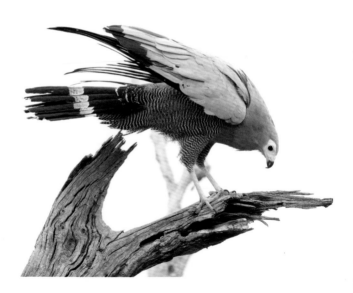

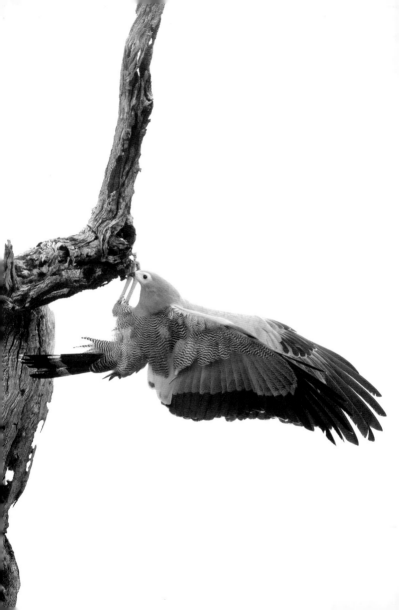

# The speedsters

This group includes raptors of the genus *Falconidae*. Falcons are striking birds and depend on speed to hunt down their avian prey. With their pointed wings and longish tails they are built for chasing birds in flight at great speed. They do, however, feed on small mammals, reptiles and insects.

The widespread and adaptable **Lanner Falcons**[1] hunt from a perch or in flight. In dry areas they favour waterholes where they ambush drinking birds that are then pursued at great speed. They sometimes hunt in pairs, one flushing the birds while the other does the catching. They also feed on mammals, reptiles and insects.
   **Peregrine Falcons**[2] are regarded as the fastest animal on Earth. When they stoop, they fold their wings towards their tails and can reach speeds of almost 400km/h. They kill their prey by striking it with the hind claws or by biting through the neck. They carry their prey off in level flight by clinging to it with their claws.

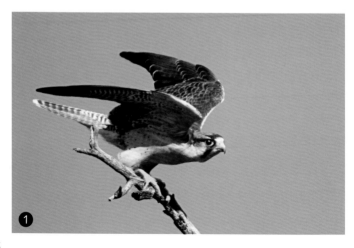

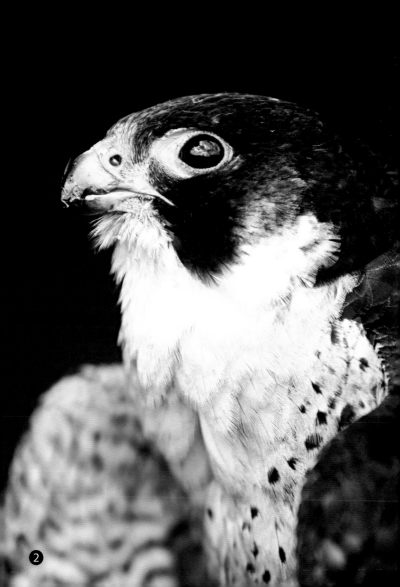

# The hovering kestrels

Although there are superficial similarities between falcons and kestrels, their habits differ considerably. Kestrels make less use of speed to catch prey. They often hunt from perches or by hovering.

The **Amur Kestrel**[1] is a widespread and common summer visitor. The **Rock Kestrel**[2] prefers open areas close to rocky outcrops. It has a varied diet which includes smaller mammals, reptiles, birds and invertebrates.

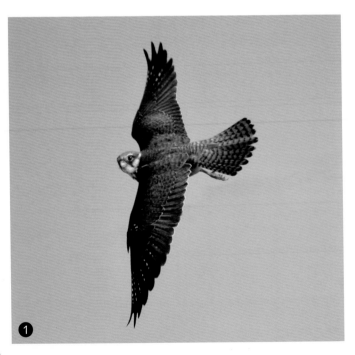

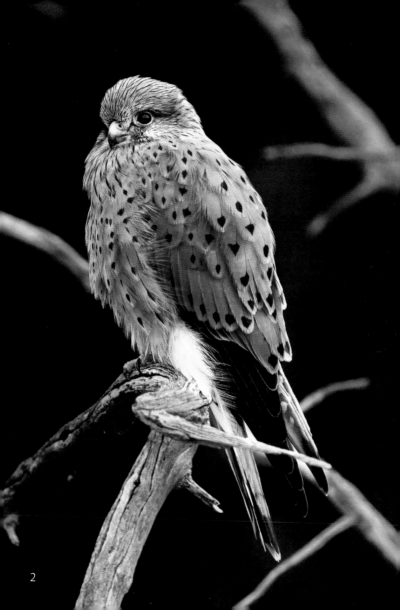

# The bird snatchers

The bird snatchers include the sparrowhawks and goshawks. They all have short, rounded wings, long tails, long legs and thin, long toes with sharp claws. These characteristics make them ideally suited to catching birds in areas with trees. They inhabit savanna and forests, hunting from a concealed perch in trees and chasing prey in a bold and dashing way.

**Little Sparrowhawks**[1] are the smallest raptors in this group. They primarily catch small birds up to their own body weight. They are often found near water where they wait in ambush for birds coming to drink. They have a habit of sitting in water for long periods.

**African Goshawks**[2] are typical hawks of the forests and dense riverine bush. They hunt from dense cover and, although they mainly hunt birds, they also feed on mammals, reptiles, insects and even crabs.

**Shikra**[3] have uniform grey upper parts and bars on the belly and breast. They have red eyes, even as sub-adults. They are opportunistic raptors that often hunt at dusk, and have a more varied diet than other accipiters.

Its grey breast distinguishes the **Gabar Goshawk**[4] from other similar-looking raptors. It is widespread and enters built-up areas. It is able to catch birds heavier than itself and also robs birds' nests. When building a nest, it incorporates a nest of colonial spiders which then cover the nest with web.

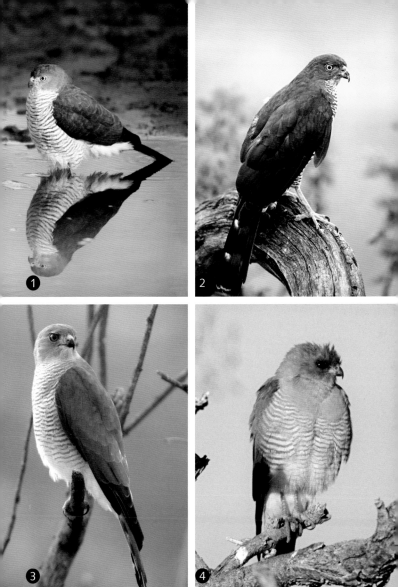

# The singing hawk

Although the **Dark Chanting Goshawk** has a similar build to other accipiters, it differs considerably with regard to behaviour and hunting methods. It is an opportunistic raptor which usually hunts from a perch. It feeds mainly on ground-living mammals, reptiles and insects but does catch birds (even those as large as Guineafowl).

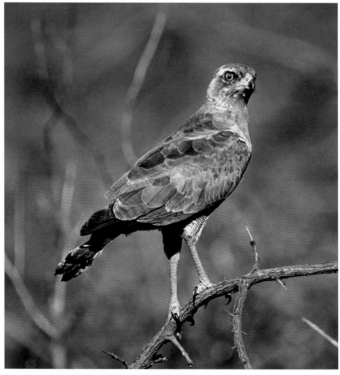

**Sub-adult**

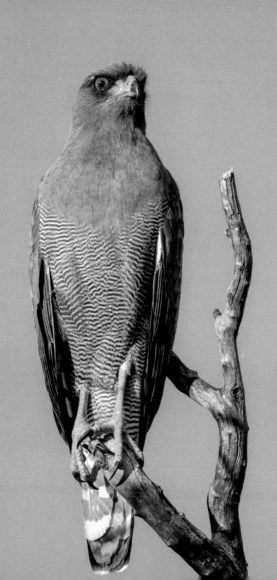

# Soaring buzzards

This group includes medium-sized raptors with broad wings. They look like eagles but have bare legs. Some of them are long-distance migrants.

**Common (Steppe) Buzzards** are palearctic non-breeding migrants. It is one of southern Africa's most common medium-sized summer visiting raptors. They favour exposed perches, but form flocks at a good food source or when migrating. They largely feed on insects but catch small birds, mammals, frogs and other reptiles.

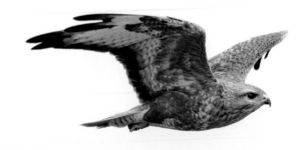

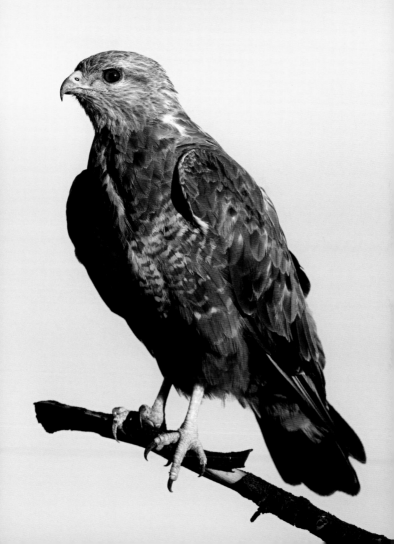

# The specialist killers

Most raptors are opportunistic hunters that prey on a wide variety of prey items. There are, however, some that are very prey-specific and selective.

The small, handsome **Black-shouldered Kite**[1] is well known for its mouse-killing capabilities. Over 90% of its diet consists of rodents but it also catches small birds, reptiles and insects. It hunts either from a perch or by hovering. Breeding birds occur in pairs and non-breeding ones roost communally. They have the habit of wagging their tails up and down when excited.

    **Ospreys**[2] have an almost worldwide distribution but are uncommon non-breeding visitors to southern Africa where they can be seen on large inland waterbodies and estuaries. They feed almost entirely on fish.

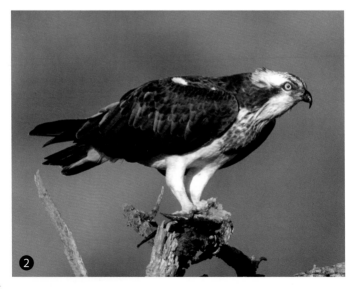

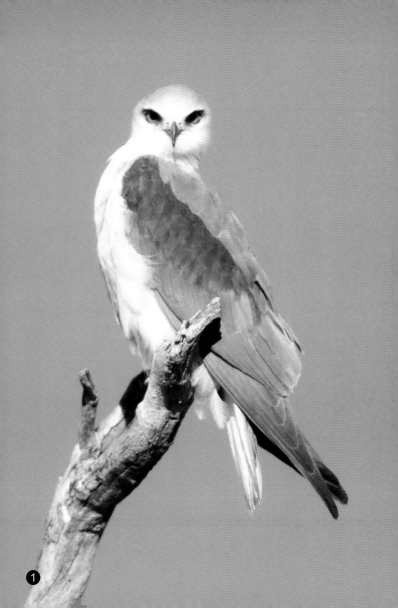

# The flying kites

In summer the local raptor population of southern Africa is augmented by two similar-looking dark brown birds of prey that arrive in large numbers: the Yellow-billed Kite and the Black Kite. Both are migrants but only Yellow-billed Kites breed here. Both groups are gregarious, especially when there is a good food source such as termites.

The dark brown body, forked tail and yellow bill and legs are identifying features of the **Yellow-billed Kite**. It feeds on smaller animals and can often be seen scavenging on road kills. When breeding they are found in pairs but form quite big flocks where there is a good food source.

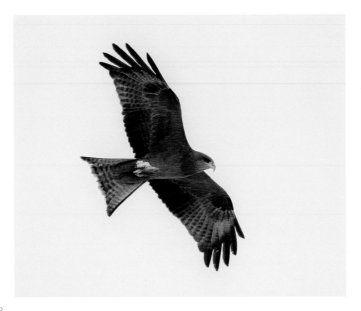

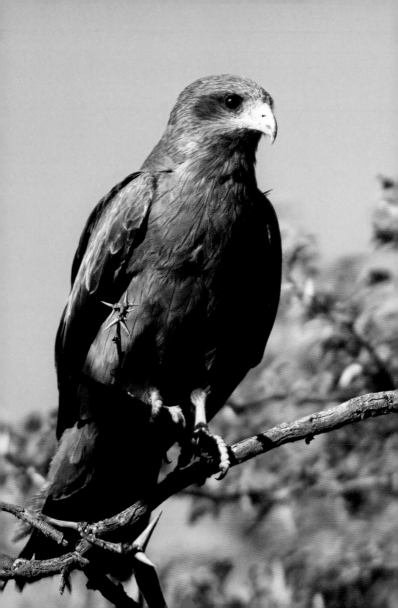

# LORDS OF THE NIGHT

This group includes all the nocturnal raptors but consists mainly of owls. When the sun sets, the diurnal raptors retire and their places are taken by owls and other nocturnal predators.

## Owls and owlets

Owls have special adaptations to hunt at night. They all have superb night vision, their hearing is extremely acute (some species can catch prey relying on their hearing only) and their flight is silent so potential prey does not hear them approaching.

The huge **Verreaux's Eagle-owl** is the nocturnal equivalent of the diurnal big eagles. It preys on a variety of larger creatures such as hares, galagos, game birds and other birds, often taken from nests. Look for these owls in tall riparian trees.

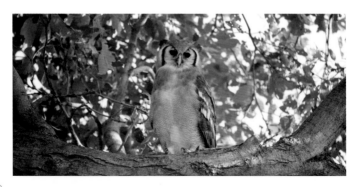

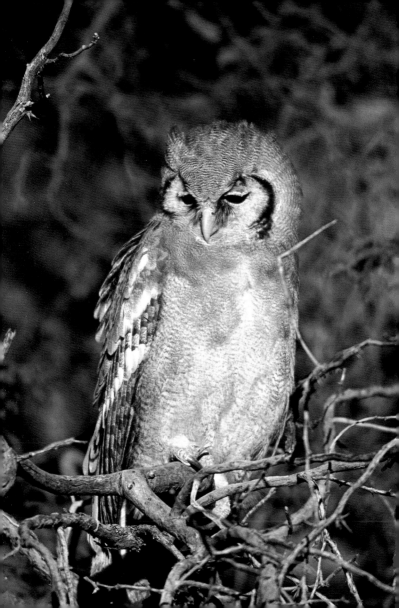

**Southern White-faced Owls**[1] are widespread in a variety of savanna types. They feed on rodents but also take birds and arthropods such as insects and spiders.

**Marsh Owls**[2] favour moist grassland and marshy areas. They hunt by flying low and dropping suddenly on to their prey, which consists largely of small rodents.

The opportunistic **Spotted Eagle-owl**[3] occurs in a variety of habitats and has a cosmopolitan diet consisting of rodents, beetles, scorpions, birds, reptiles and even bats. It is often found in built-up areas such as rest camps in reserves and suburban gardens.

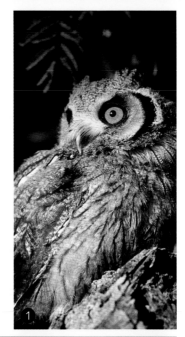

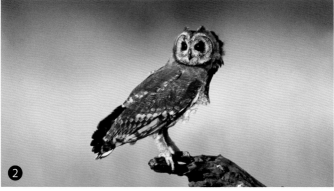

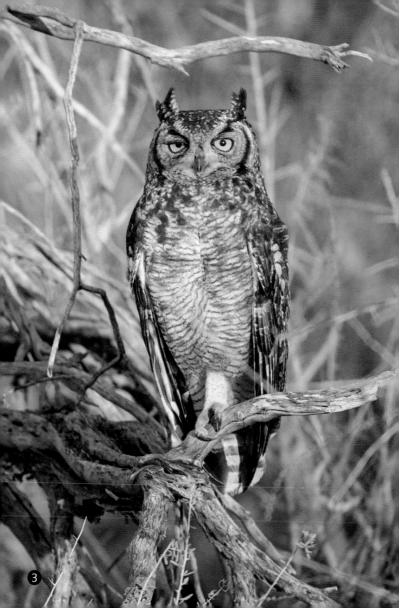

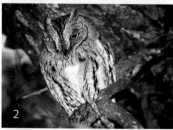

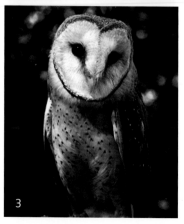

**African Barred Owlets**[1] prefer areas with tall trees and broad-leaved bushveld. They feed mainly on athropods but small vertebrates are caught.

**African Scops-Owls**[2] are masters of camouflage and during the day perch against stems or branches with half-closed eyes and are not easy to see. They feed primarily on insects but also catch small vertebrates.

The common and widespread **Western Barn Owl**[3] is strictly nocturnal. It hunts from a perch or by flying slowly over suitable habitat to locate prey. It feeds on rodents but other smaller vertebrates and insects are also taken. Prey is swallowed whole.

**Pearl-spotted Owlets**[4] are aggressive and bold hunters of birds (even bigger than themselves), rodents and insects. Their beautiful call can often be heard during the day.

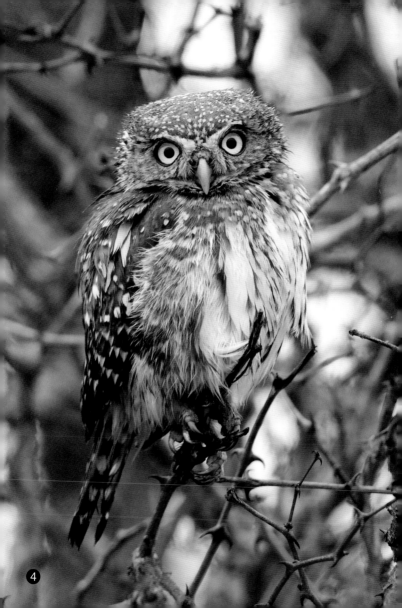

**Pel's Fishing Owls**[1] are indeed a special sighting for any visitor to the wild. They are rare and occur in riverine bush along permanent rivers. As the name implies, they catch fish.

The well-camouflaged **African Wood-owl**[2] is a real forest bird more often heard than seen. It hunts by dropping on to prey consisting of insects and smaller vertebrates.

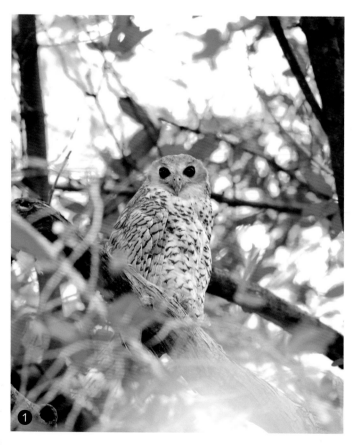

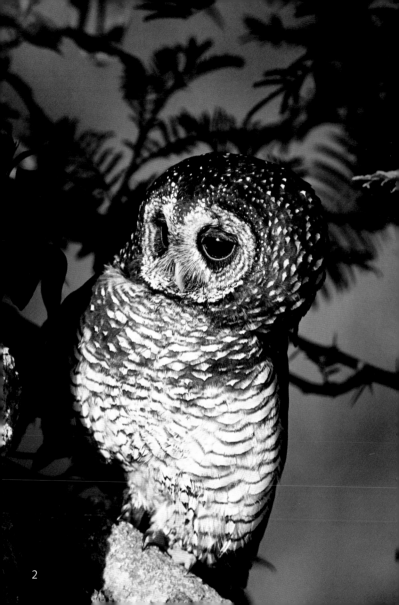

# THE UNDERTAKERS

This group includes all the birds of prey that depend on scavenging to obtain their food. They do not have the specially adapted claws of other raptors to kill prey but some occasionally do so. It is important to note that all predatory birds are opportunistic and most will feed on carrion when available. Raptors such as the Bateleur and the Tawny Eagle often arrive first at a dead animal, and Yellow-billed Kites regularly patrol roads to pick up road kills.

# The vultures

Vultures are large, carrion-feeding birds with strong, curved bills. Most of them have bare necks and heads. When the air has heated up sufficiently in the morning to cause thermals, they take to the wing to forage over a large area. The first one to notice potential food will fly down and the others will follow it in spiralling flight.

The large **White-backed Vultures** are the most common vulture in savanna areas. They breed and roost in trees and when not breeding are gregarious. They are aggressive at a carcass and feed mainly on the softer parts of large animals.

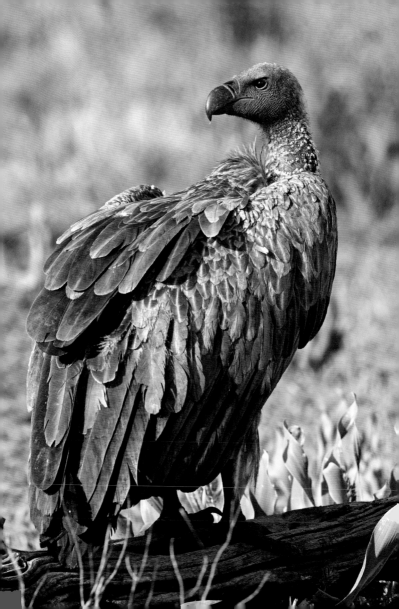

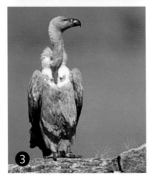

The pink, bare face and triangular shape of the head are identifying features of the rather handsome **White-headed Vulture**[1]. They start to fly earlier in the morning and often arrive first at a carcass. They also feed on the bodies of smaller mammals and birds and are known to kill their own prey. Like most raptors, they love termites.

The medium-sized **Hooded Vulture**[2] has a dark body, a pink face without plumage, and a slender bill. It cannot compete with other vultures at carcasses and picks up scraps and clean bones after others have finished. It also feeds on insects in dung and soil.

The very large, endangered **Cape Vulture**[3] is endemic to southern Africa. They are gregarious and nest and roost on precipitous cliff ledges from where they forage over the surrounding area. The eyes of adults are yellow and they have bluish necks.

The huge **Lappet-faced Vultures**[4] are dominant at a carcass. They have massive bills that enable them to rip open a carcass and to feed on tougher body parts such as skin, sinew and bone. Despite being mainly a scavenger, it is known to kill its own prey and will feed on emerging winged termites. They never arrive in big numbers at carcasses. The head is bare and has conspicuous skin folds.

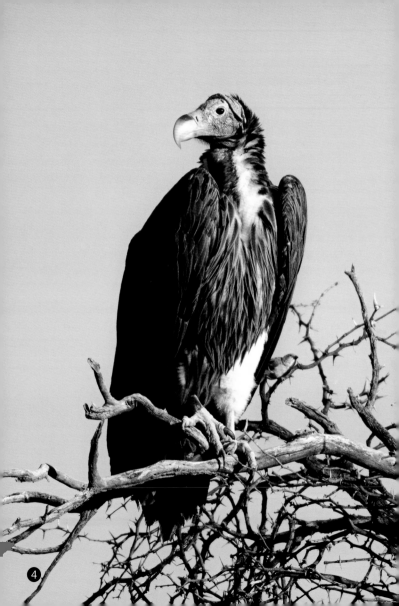

# BIRDS AT THE WATER

Grey heron

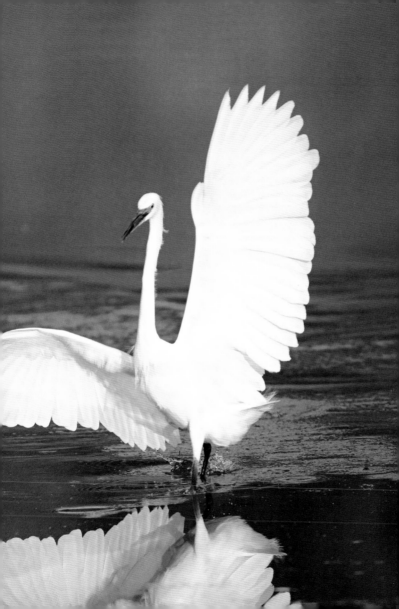

# BIRDS AT THE WATER

A waterbird can be defined as a bird that feeds in or around water. Their diet consists of aquatic life such as fish, frogs, reptiles, crustaceans, molluscs, insects and aquatic vegetation. The vast range of potential food items can be exploited only if waterbirds have specific functional adaptations in form and habits. It is therefore not surprising they have such a variety of anatomical features such as the shape and size of their bills, legs, necks and feet.

## Flat-billed waterbirds

Where there are suitable stretches of water, expect to see one or more species of duck or goose. All have webbed feet and flattened bills. They feed on plant and animal matter.

**Egyptian Geese** are probably the most often seen of this family. When not breeding or during moult, they form flocks. When breeding, they form mating pairs and become aggressive and territorial.

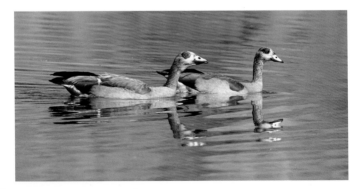

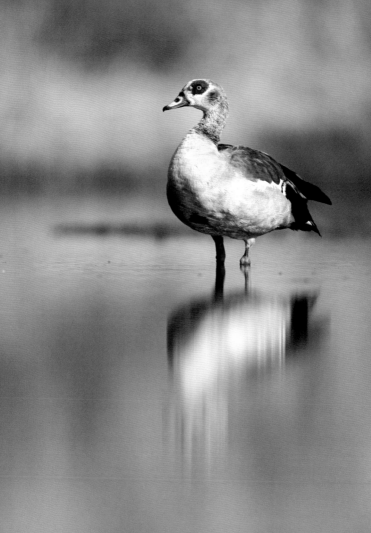

**Knob-billed (or Comb) Ducks**[1] are associated with savanna and woodland regions where they forage on floodplains and at pans with surface vegetation. During breeding time, the males develop huge knobs on their bills.

**Spur-winged Geese**[2] are the largest in the family and can be distinguished by their metallic back plumage and white underparts. The male has a knob on its forehead. They are plant feeders and fly long distances to feed on suitable plants. During moult they congregate in great numbers on large stretches of open water .

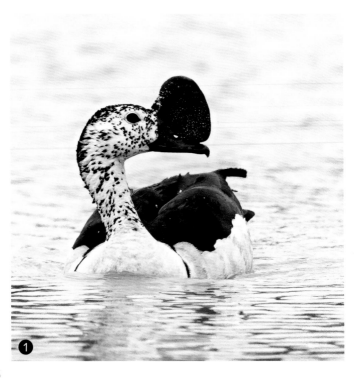

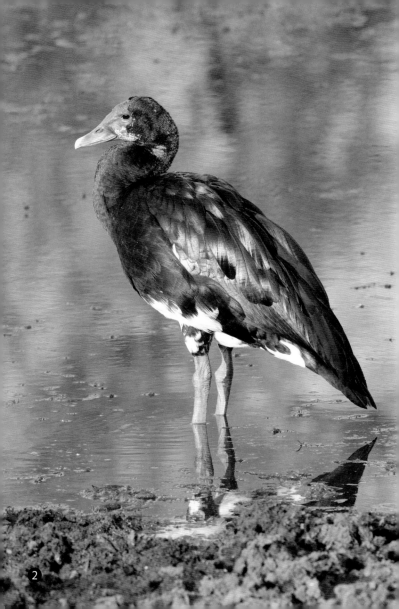

**White-faced Whistling Ducks**[1] are widespread and can sometimes be seen in huge flocks. When breeding, they occur in pairs and small groups. Breeding pairs tend to preen each other often. They have a characteristic whistling call.

Look for **Fulvous Whistling Ducks**[2] in overgrown pans. They are gregarious and feed mainly by diving. They spend a lot of their time in large inactive groups.

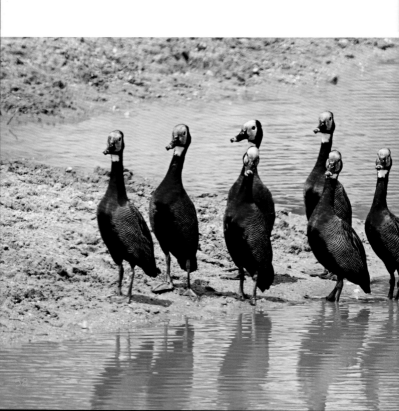

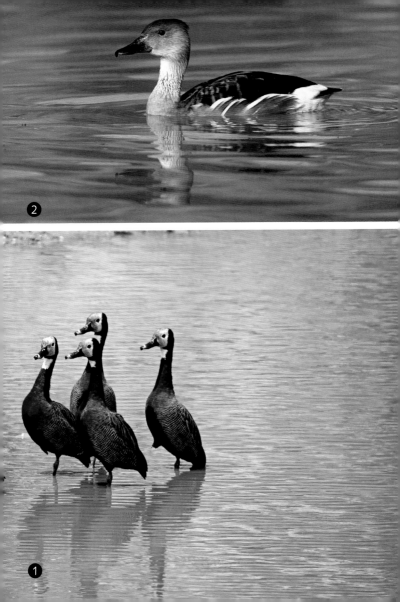

**African Pygmy-Geese**[1] occur in subtropical areas where they prefer open water with water lilies. They feed almost exclusively on water lily seeds and flowers, but also on other plants and insects.

**Cape Shovellers**[2] are near-endemics favouring shallow water, obtaining food by dabbling below the water surface while swimming. The male has yellow eyes and the female brown eyes.

**Yellow-billed Duck**[3] are common over most of the region. They prefer open water and feed on plant material, including domestic grain. They obtain food in water by dabbling or up-ending.

The male **Southern Pochard**[4] has characteristic red eyes. It prefers open, clean water and gathers in large numbers at a good food source. It feeds on plant and animal matter.

**Red-billed Teals**[5] prefer dams and pans. They feed mainly on aquatic plants obtained by immersing the bill or by up-ending. They form huge flocks when not breeding.

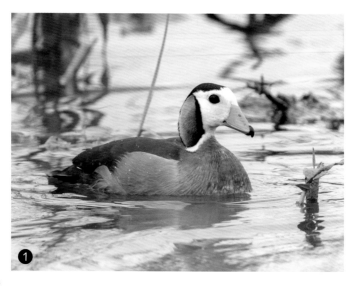

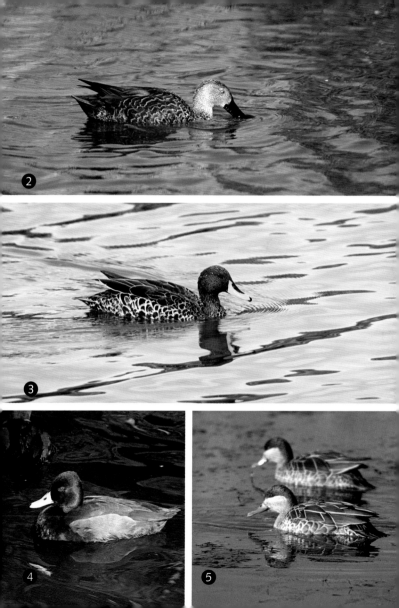

# Spear fishers

Herons and egrets are usually found near water and vary in size from small to very large. They have long legs, bills and necks which are kept folded when flying. They feed by wading and waiting patiently for prey. Their food consists of aquatic animals which they catch with their bills, either by spearing or grabbing, and then swallow whole.

**Goliath Herons** are the world's largest herons. They forage in the shallows of large bodies of water such as dams, pans and rivers, standing in the water for long periods waiting for prey that is speared with their huge bills.

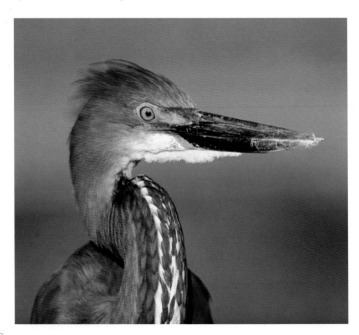

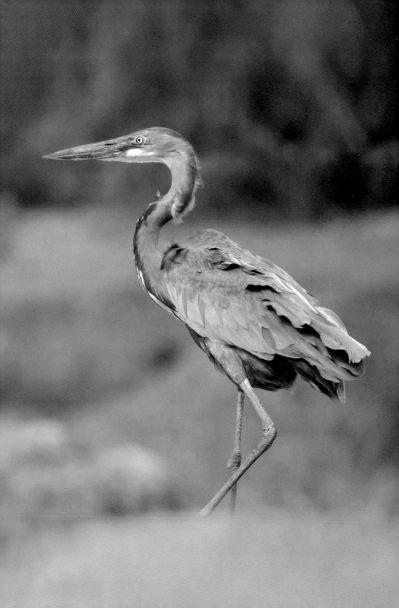

**Purple Herons**[1] like dense vegetation, especially reeds. When they feel threatened, they turn their bills upwards to blend in with the vegetation. They use their sharp bills to spear their prey that is then swallowed whole.

**Grey Herons**[2] are common, widespread residents that prefer shallow water where they catch fish and frogs. They are normally solitary but sleep in groups in trees. The bill turns bright orange and the legs pinkish during breeding.

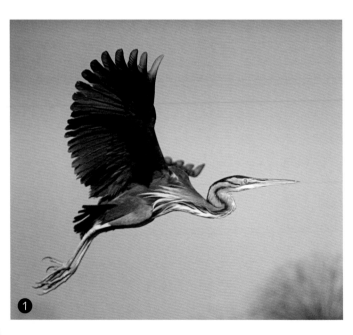

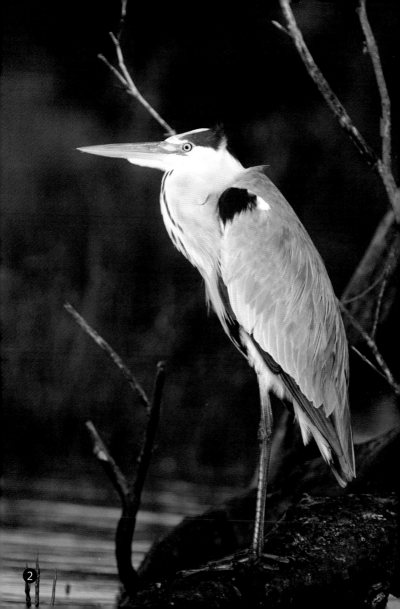

The all-white **Little Egrets**[1] have a black bill and legs, yellow feet, and plumes at the back of the head. They are active hunters in shallow water, often stirring the bottom with their feet.

**Great Egrets**[2] are all white with a long necks. Non-breeding adults have yellow bills, but during the breeding season these turn black and the ceres greenish colour. Their prey consists mainly of fish but they also take frogs, reptiles and insects.

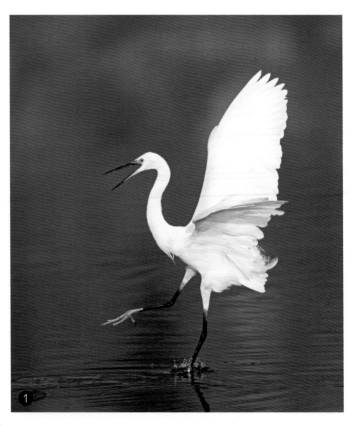

1

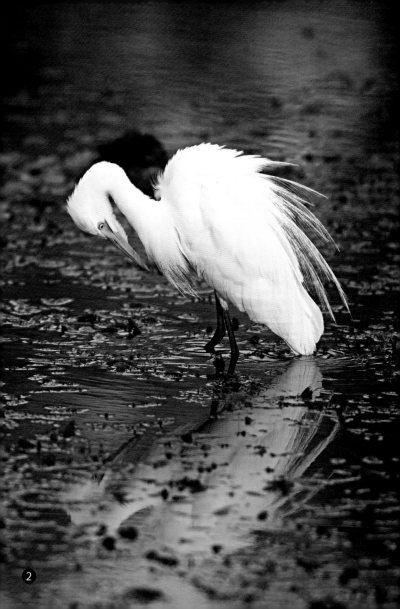

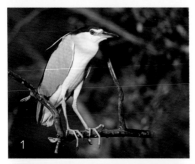

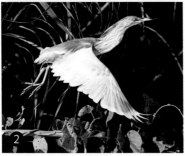

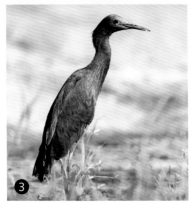

The largely nocturnal **Black-crowned Night-Heron**[1] hunts from a low perch over water. It feeds on fish, frogs, crustaceans, molluscs, insects and spiders. Although often seen alone, they are normally gregarious when breeding or roosting.

**Squacco Herons**[2] prefer quiet waters with plenty of vegetation. They are shy and therefore easily overlooked. The white wings are conspicuous when they fly.

**Black Herons**[3] have the interesting habit of creating a canopy over their heads with their wings when fishing to eliminate reflections so that they can see better into the water. They favour marshes and wetlands.

**Green-backed Herons**[4] are small and short-necked. They prefer stretches of water with surrounding vegetation. When disturbed they will, like the Purple Heron, take an upright stance with bill pointed upwards and are then not readily seen. Interestingly, they use bait to attract prey.

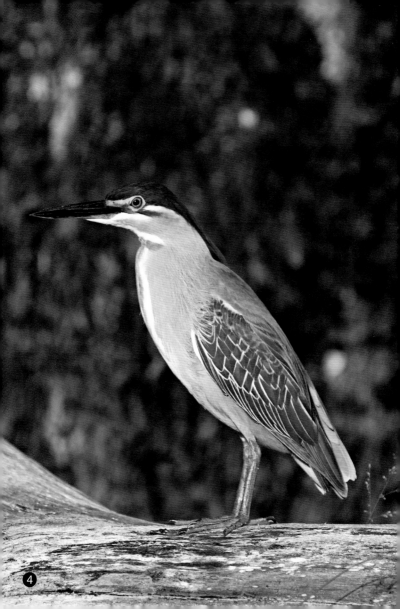

④

# The snappy grabber

Hamerkops are the only species in its family.

**Hamerkops**[1] snatch prey lightning-fast while wading or flying slowly over the water surface. They build huge nests with a small opening in trees or on rock ledges. Part of their display is to stand on each other's backs.

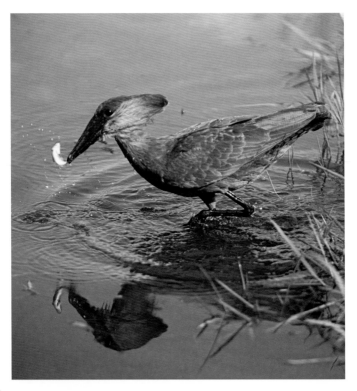

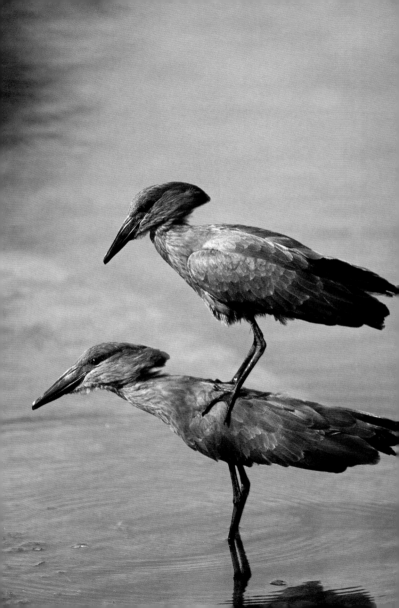

# The probers

Storks are tall birds with large, long bills and long necks
which are extended in flight. Of the eight species to be
seen in the region, five are associated with water. The
others are mainly grassland birds but may visit water when
there is an available food source, or to drink and cool down.
The Marabou Stork discussed under scavengers will, for
instance, visit drying pools to feed on stranded fish.

**Black Storks**[1] are not often seen as they are uncommon and they
are regarded as near-threatened. They have a preference for moun-
tainous regions.
  **Saddle-billed Storks**[2] are huge birds with enormous black and
red bills with yellow saddles. The males' eyes are dark and the fe-
males' yellow. They forage in shallows of larger bodies of water.

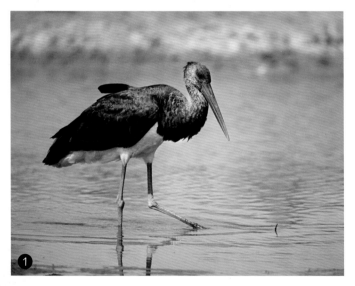

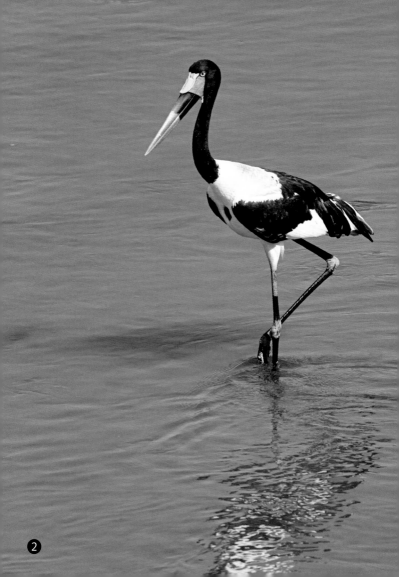

**African Openbills**[1] are all-black, glossy birds with a wide gap between the upper and lower parts of the bill, a special adaptation enabling them to feed on freshwater molluscs. The sharp lower mandibel is inserted into the shell to extract the contents. Mussels are sometimes left in the sun to open.

**Yellow-billed Storks**[2] are gregarious and forage in small groups. They move their bills from side to side feeling for prey disturbed by their feet, and they often open one wing to form a canopy when fishing.

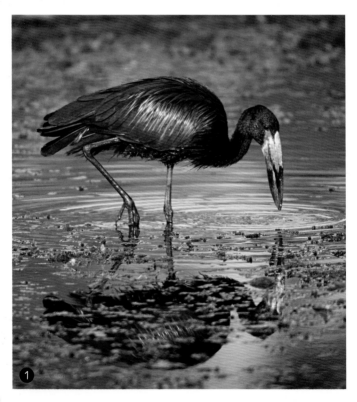

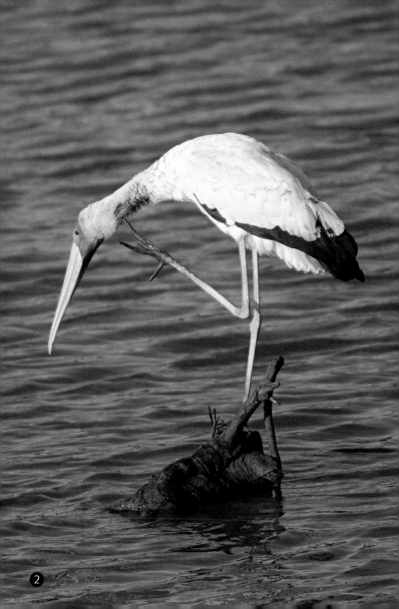

**Woolly-necked Storks**[1] prefer wooded areas where they feed in whatever water they can find. They usually forage alone or in pairs in shallow water, and sometimes also in grassland.

The huge **Marabou Storks**[2] are often seen at a carcass where they will peck at vultures to get them out of the way. Like the vultures, they have a bare head and neck. They congregate at drying pools to feed on stranded fish, and eat insects and smaller vertebrates.

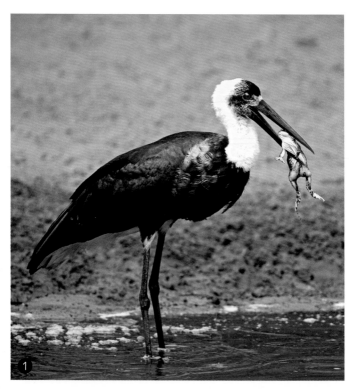

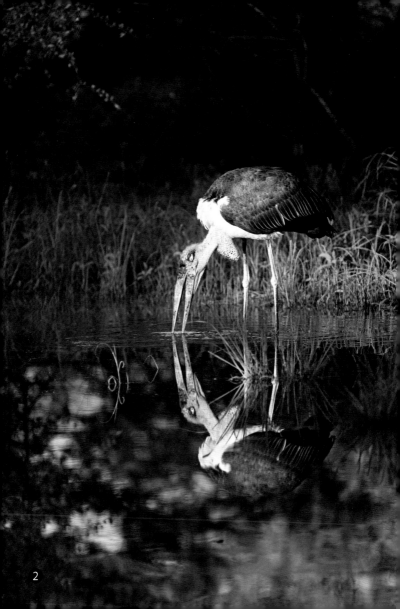

# The odd-bills

This family has five species in southern Africa. They are large waders that feed on a variety of animal matter as well as carrion and detritus. The ibises often forage in grassland by probing. The ibises have long, downward-curving bills and those of the spoonbills are straight and spatulate.

The harsh, loud call of the **Hadeda Ibis**[1] is a well-known African sound. These birds are often seen at water, but spend most of their time foraging in grassland. They have adapted well to urban areas and favour lawns where they probe for food. They are opportunistic and will even scavenge from open dustbins.

**Glossy Ibises**[2] have a wide distribution but are not found in the dry areas of the region. They feed on invertebrates and other animal matter in open waters and flooded grassland.

**African Sacred Ibises**[3] prefer to forage in shallow water or grassland with wet soil and can often be seen on rubbish dumps. They have a very varied diet that could even include carrion as well as eggs, birds and young crocodiles.

**African Spoonbills**[4] forage in shallow water by walking slowly and sweeping their bills from side to side or by probing mud. They feed on small fish, aquatic insects and crustacea, and breed in colonies.

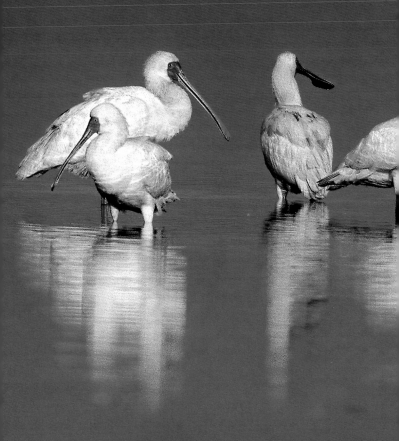

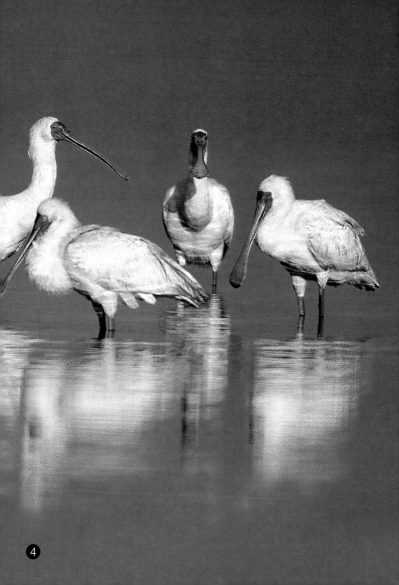

# The submarines

Four species of three different families obtain most of their prey by diving and swimming underwater. These include two cormorants, the African Darter and the Little Grebe. They have specific adaptations with regard to their bills and feet as well as feathers to enable them to pursue and catch prey underwater.

**Reed Cormorants**[1] are common wherever there are suitable stretches of water. In pursuing prey they dive underwater propelling themselves with their webbed feet. The sharp hook at the tip of their bills enables them to grab prey, which is swallowed whole after surfacing. Fish are always swallowed head first.

   **Little Grebes**[2] are seldom seen out of water. These nomadic birds fly at night to other suitable stretches of water. They can remain underwater for surprisingly long periods, catching small aquatic animals.

   **White-breasted Cormorants**[3] feed mainly on fish caught underwater. They catch surprisingly big fish, manoeuvring them in their bills before swallowing them head first. They prefer larger areas of water.

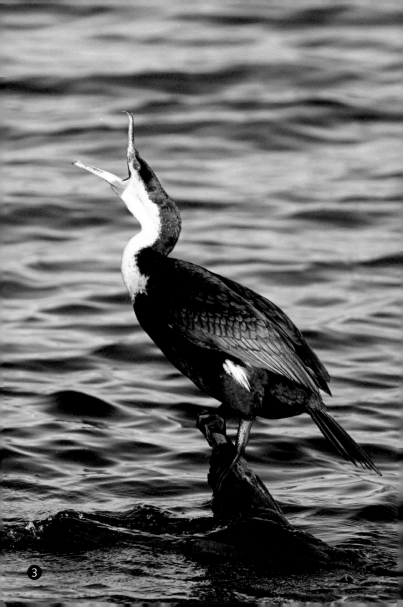

③

**African Darters** have similar hunting strategies to cormorants but they spear their prey with their long, sharp bills. They feed mainly on fish, but will catch frogs, insects and crustaceans. After fishing they sit on a perch and open their wings to dry.

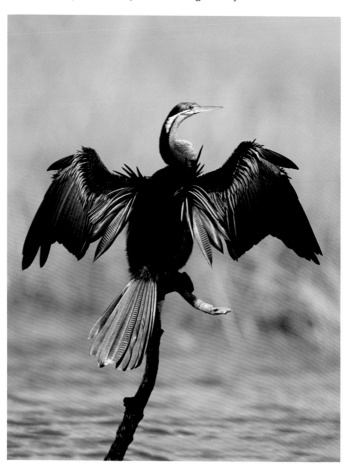

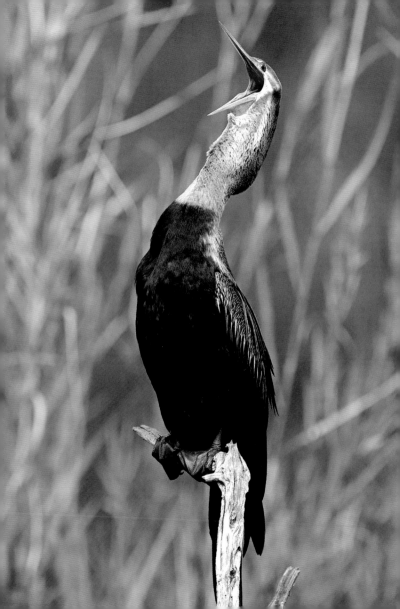

# Swimmers and divers

Many omnivorous aquatic birds forage by swimming and diving. They can often be seen resting at the water's edge, but most of their time is spent swimming.

**Common Moorhens**[1] are widespread residents and can be seen in most freshwater habitats with marginal vegetation. They have a varied diet of plants, insects, spiders, worms and tadpoles.

The uncommon and highly secretive **African Finfoot**[3] is indeed a highly sought-after species for birders and others visiting wilderness areas. It favours quiet stretches of water with overhanging vegetation.

**Red-knobbed Coots**[2] build floating platform nests on which they spend quite some time. They feed mainly on plant material.

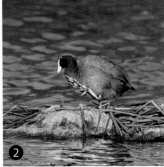

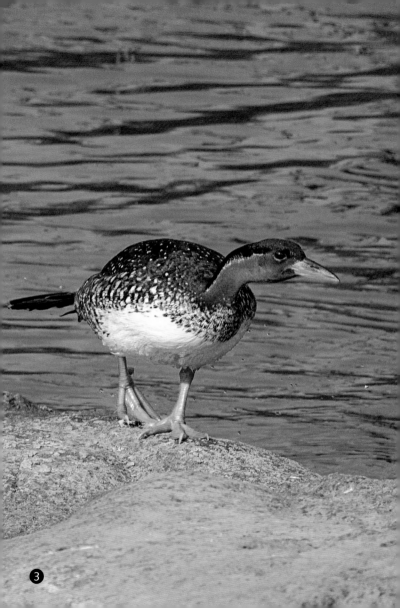

❸

# The women's libbers

Two species of closely related families are extraordinary in the sense that the females behave differently to most birds. These are the African Jacana and the Greater Painted Snipe. In both cases the females are larger than the males. The Greater Painted Snipe takes it a step further – the female is more richly coloured. The females of both species mate with different males and leave most of the breeding and parental care to the males.

The shy **Greater Painted Snipe**[1] prefers wetlands with lots of vegetation where it forages for invertebrates and seeds. The richly coloured female is polyandrous and leaves most of the parental care to the male.

    **African Jacanas**[2] have extraordinarily long toes that enable them to walk on floating vegetation. They feed on invertebrates and seeds. The male holds the eggs under its wings when sitting on the nest and also carries the fledging under its wings.

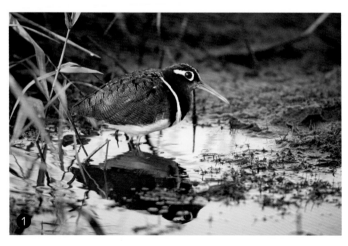

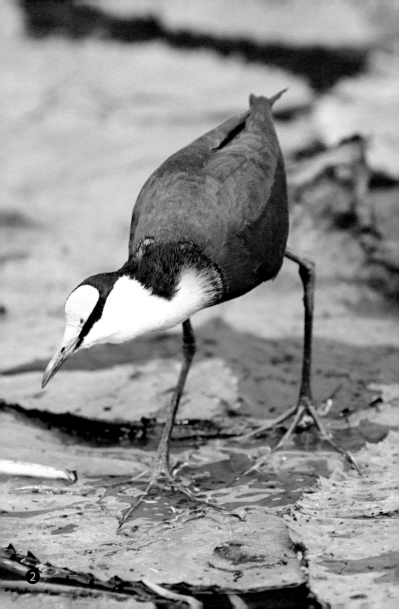

# Plovers

Plovers are small waders with shortish legs and bills. They favour shallow water or open areas next to water. They breed on the ground and use very little nest material. The chicks are precocial (i.e. they move and feed directly after hatching).

**Common Ringed Plovers**[1] are long-distance migrants (up to 12 000 km). They breed over a wide area in the northern hemisphere and some visit southern Africa as non-breeding migrants.

**Kittlitz's Plovers**[2] are less water-bound than other plovers and can sometimes be seen foraging in open areas away from water. They lay their eggs in a mere scrape, and when they feel threatened will quickly cover the eggs and move away.

**Three-banded Plovers**[3] are quite common and can be seen at pans, rivers, dams and temporary rainwater pools. They forage at the water's edge or in shallow water and feed on crustaceans, insects, worms and molluscs.

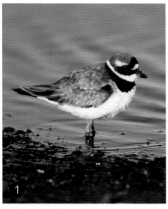
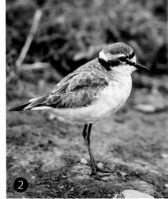

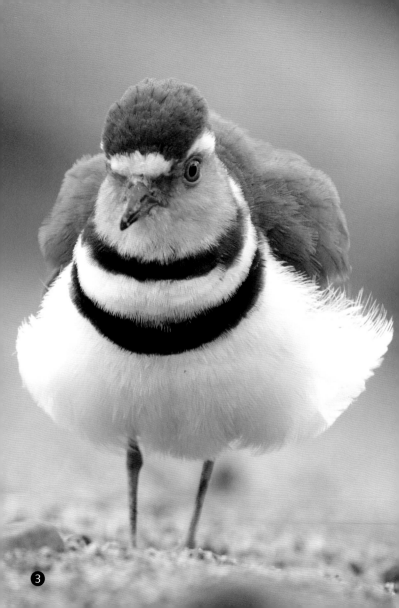

# Lapwings

Lapwings have longer legs than plovers and are larger. Not all the lapwing species are associated with water. You can expect to see four species at water or in damp places close to water.

**African Wattled Lapwings**[1] are seen close to water in moist, grassy areas, on mud and sand banks or on the shoreline. They feed on frogs, fish and insects. They have conspicuous spurs on their wings.

    **White-crowned Lapwings**[2] are localised birds, preferring bigger rivers where they forage on mud and sand banks or on the shoreline. They feed on frogs, fish and insects. They have conspicuous spurs on their wings.

    **Blacksmith Lapwings**[3] are widespread and can often be seen foraging in shallow water or on the shoreline. Their call is a characteristic metallic 'klink, klink, klink' like a hammer on an anvil, hence the name.

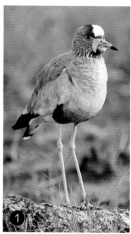

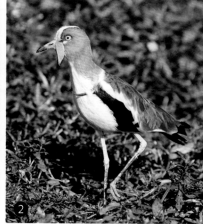

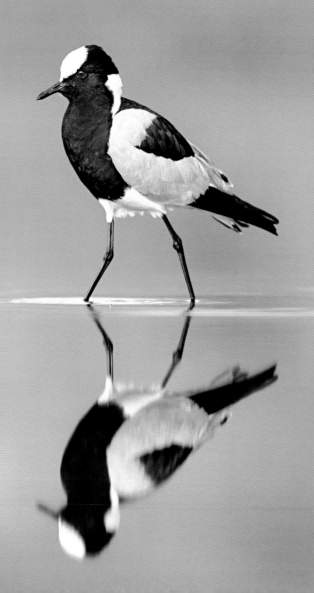

# The secretive squad

There are quite a number of birds that forage in shallow water with plants. All these bird are secretive and not easily seen. They can best be observed by sitting in a hide or vehicle next to water.

**African Purple Swamphens**[1] (Purple Gallinules) are colourful, shy birds that forage in reeds, rushes and sedges. They feed on plants as well as a variety of animal matter such as insects, nestlings, eggs and even carrion.

**African Crakes**[2] are uncommon breeding migrants with fluctuating numbers, depending on rainfall. They prefer water with lots of vegetation and even temporarily flooded grassland.

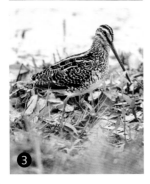

The **African Snipe**'s[3] bill is more than twice the length of its head. It prefers shallow water in brackish or freshwater wetlands where it feeds on aquatic insects and other smaller creatures.

**Black Crakes**[4] are not as shy as others of their family and can regularly be seen where there is suitable water for foraging. They feed on a variety of arthropods but also small fish, bird nestlings, eggs and some seeds and water plants.

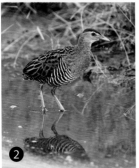

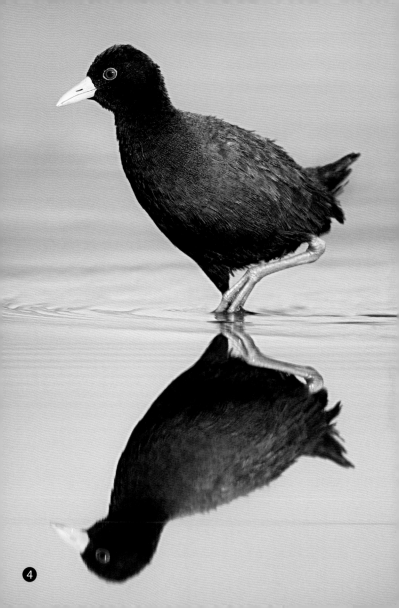

# International visitors

A multitude of non-breeding palearctic waders visits southern Africa annually. They are all brown, inconspicuous birds in their non-breeding region, but many of them develop elaborate breeding plumage where they breed.

**Common Sandpipers**[1] are smallish waders occurring on almost any shore-line. They feed on crustaceans, insects, molluscs and even fish fry. They breed in Eurasia and Japan and migrate south to southern Africa and even Australia.

**Common Greenshanks**[2] can be distinguished by their slightly up-turned bills and greenish legs. They occur widely in inland and marine water habitats.

The backs of **Ruffs**[3] are heavily mottled and their bills shortish and thick at the base. The male is consid-erably larger than the female and in their breeding grounds it develops a striking plumage.

The olive-brown spotted back and yellowish legs are characteristic of **Wood Sandpipers**[4]. They forage in shallow water or moist grass. They breed in northern Europe and Asia but some remain in the south throughout the year.

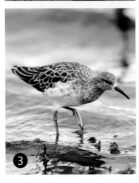

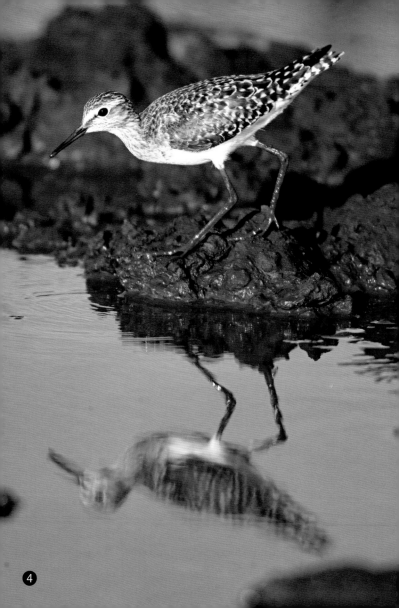

# Avocets and stilts

The birds in this group have particularly long legs, thin bills
and black and white plumage. They inhabit shallow water
where they feed on a variety of aquatic animals. At times
they are found in large numbers in suitable habitats. Only
two species occur in southern Africa.

**Pied Avocets**[1] have long, grey legs, upcurved, thin bills and black
and white plumage. They forage by wading in shallow water and
sweeping their bills from side to side over the surface. They feed on
invertebrates, small fish, seeds and plants.

  The long, red legs and dark backs of **Black-winged Stilts**[2] are
characteristic. These highly nomadic birds forage by wading quickly
and catching edible items on the surface, or with their heads under
the water. They feed on a variety of invertebrates and seeds.

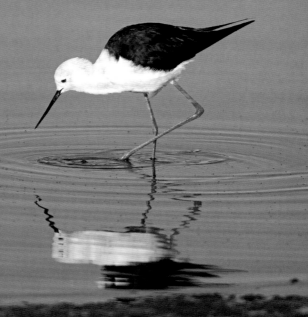

# Thick-knees

Thick-knees are lapwing-like birds with big eyes, thick knees and they have no hind toes. They are nocturnal birds. There are two species in the region, with only one associated with water: the Water Thick-knee.

**Water Thick-knees** occur in the wetter parts of the region at rivers, dams, pans, mangrove swamps and beaches. They feed on insects, crabs, frogs, molluscs and small fish.

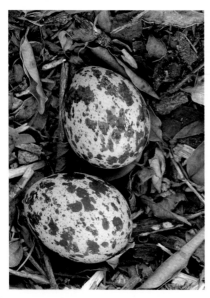

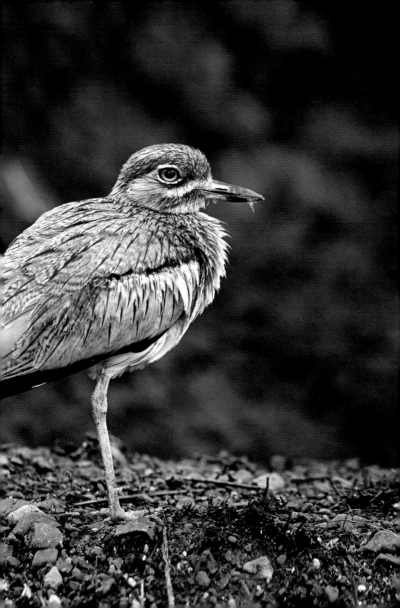

# Wagtails

Wagtails get their name by their habit of wagging their rather long tails up and down.

**Cape Wagtails**[1] can be seen at dams and rivers, and have adapted well to urban areas.

**African Pied Wagtails**[2] are the largest of the wagtails. These black and white birds can be seen along rivers and in other wet places, and sometimes also in gardens. They feed mainly on smaller arthropods.

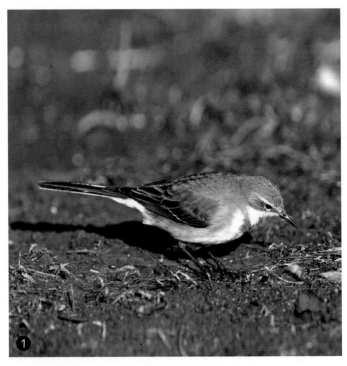

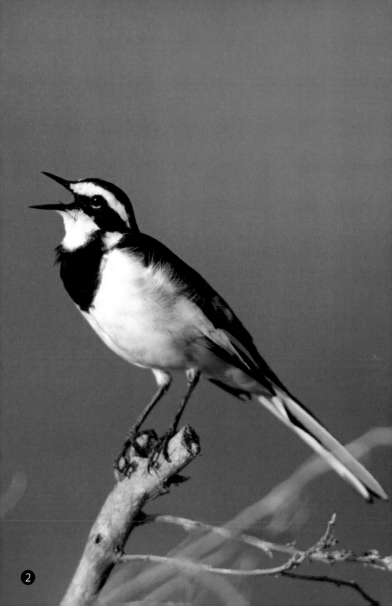

2

# The dive-bombers

Some fish-eating birds catch their prey by diving into the water. They use a perch from which to scan the water, but some do so by hovering. Fish are caught with talons like the African Fish Eagle, the Osprey and the Pel's Fishing-Owl, while others such as the kingfishers catch fish with their bills.

**Malachite Kingfishers** are quite common over the eastern part of the region. These strikingly colourful little jewels of the waterways prefer water with marginal vegetation. They perch low over water in trees, bushes or reeds and dive for prey. They feed on tadpoles, fish, insects and crustaceans.

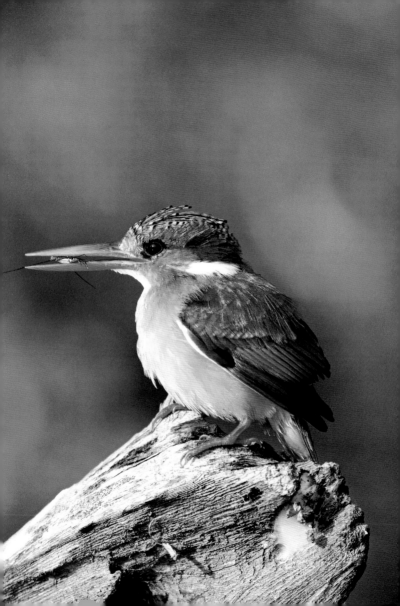

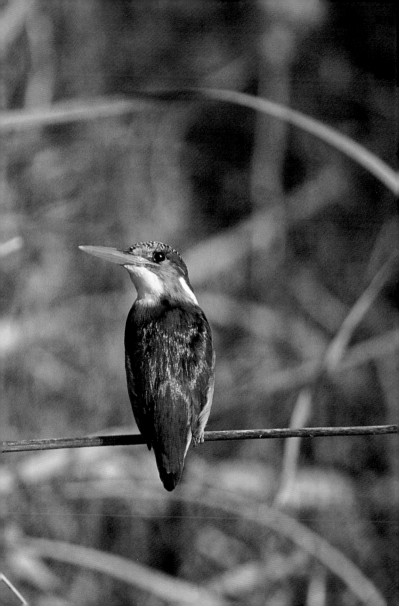

**Pied Kingfisher**[1] are common at rivers, lakes and dams. They fish either from a perch or by hovering with the body held in an almost upright position. They feed mainly on fish.

The **Giant Kingfisher**[2] is the largest kingfisher in southern Africa. They prefer perennial rivers and hunt from a perch such as a rock or low branch, seldom by hovering. They prey on fish, crabs and insects.

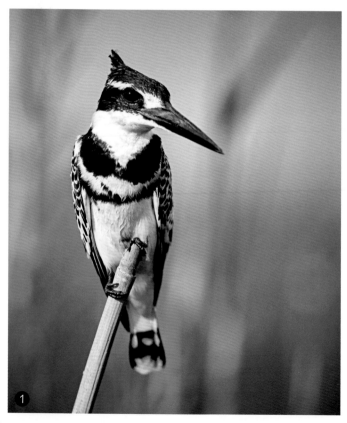

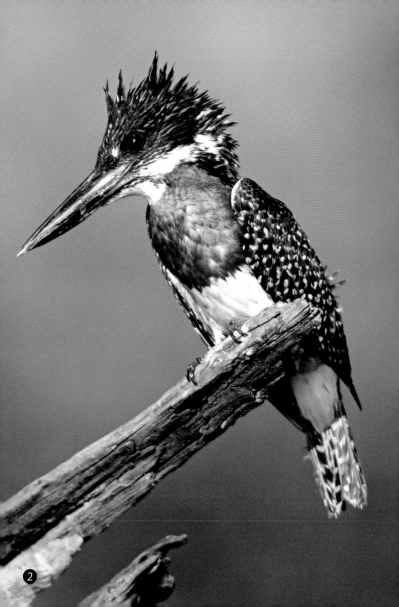

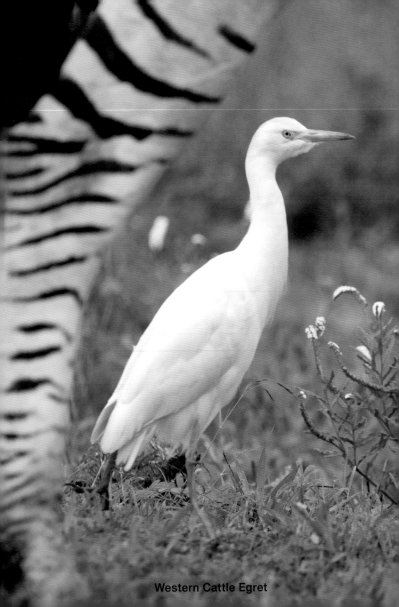

Western Cattle Egret

# GROUND-LIVING BIRDS

# GROUND-LIVING BIRDS

This section includes all the terrestrial birds. A terrestrial bird can be described as a bird that obtains its food at ground level and breeds on the ground. Most ground-living birds are not easily seen, as they have subdued colours for camouflage. Because of their foraging habits they also fly less often than other birds.

## The Giant

The largest of all birds, the **Common Ostrich**, is a terrestrial and flightless bird that obtains all its food, consisting of plant material, at ground level. They occur in flocks when not breeding.

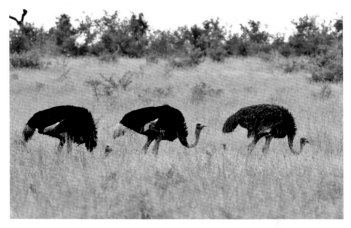

# The terrestrial hornbill

Although **Southern Ground Hornbills** roost and mostly nest in trees, they forage while walking on the ground. They feed on insects, molluscs, frogs, reptiles (including snakes and tortoises) and mammals as large as hares.

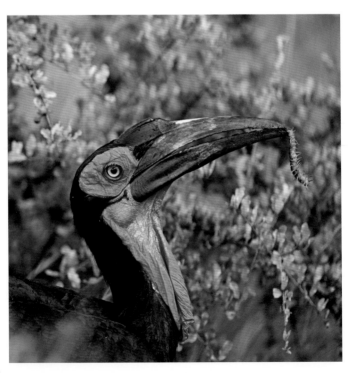

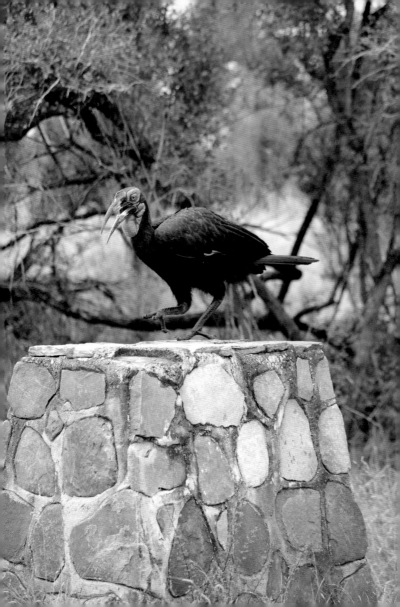

# The Hunter-bird

**Secretarybirds** prefer open areas that they patrol, looking for prey such as insects, birds, reptiles, mammals and amphibians. They subdue larger prey with hard downward blows of their feet.

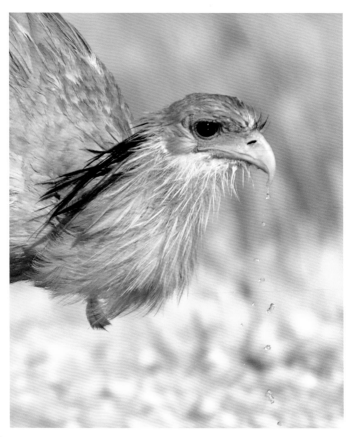

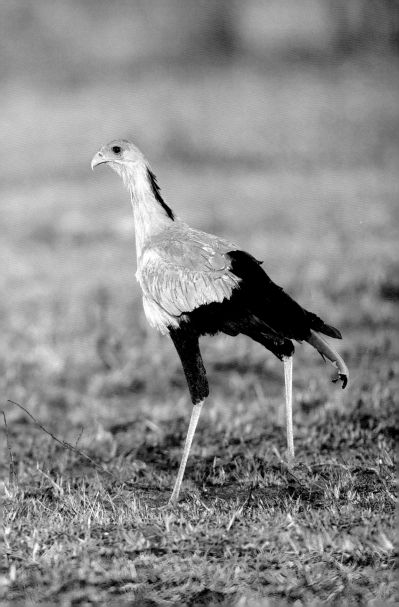

# Bustards and korhaans

This family is strictly terrestrial. They have long necks and legs, with short toes (the hind toe is absent) and are cryptically coloured. During breeding time the males get involved in elaborate displays.

**Black-bellied Bustards**[1] occur in a variety of habitats. In summer the males often call from an elevated perch. They feed on insects and plants.

The **Red-crested Korhaan**[2] male performs a spectacular display flight – flying straight up into the air and then tumbling down as if shot. The red crest is also opened in display but is otherwise seldom seen.

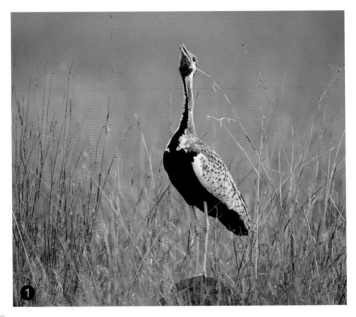

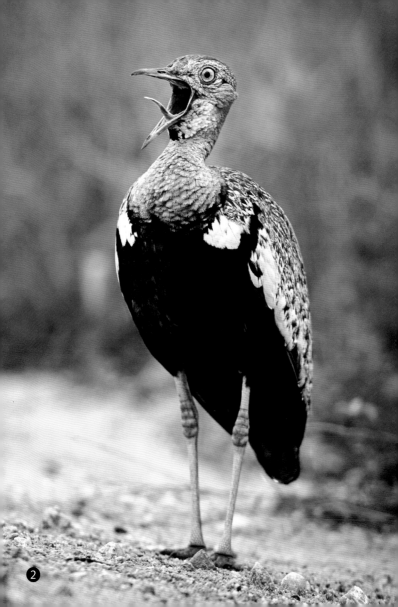

**Kori Bustards** are the heaviest birds capable of flying. They prefer open savanna where they feed on insects, reptiles and fruit. The Afrikaans name gompou ('gum peacock') is from its habit of eating tree gum or resin.

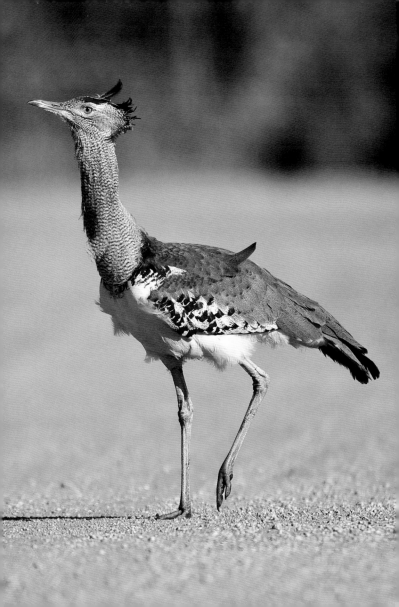

# Herons and storks

Although most heron and stork species are aquatic birds, two species of each group are terrestrial and prefer open areas not necessarily close to water. These are Black-headed Herons, Cattle Egrets, Abdim's Storks and White Storks.

**Cattle Egrets**[1] are common over the whole area and their range has expanded worldwide. They often accompany grazing animals to catch insects and other prey disturbed by the grazers.

**Abdim's Storks**[2] are non-breeding intra-African migrants that visit the region in large numbers. They are insectivorous, and large flocks can be seen at insect outbreaks such as the emergence of termites after rain.

**White Storks**[3] are common and widespread non-breeding summer visitors from the northern hemisphere. They favour grassland, cultivated fields and open woodland.

**Black-headed Herons**[4] are common residents and widespread in grassland areas. They feed primarily on insects but also catch vertebrates.

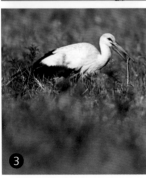

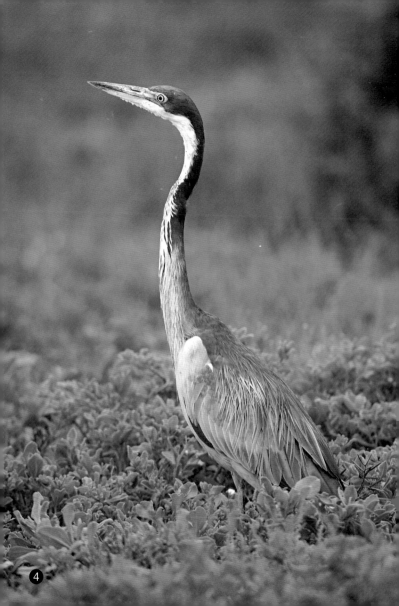

# Long-legged runners

Birds in this group are all very terrestrial, obtaining all their food at ground level, and they also breed on the ground.

**Spotted Thick-knees**[1] are common, widespread residents. They favour open areas, including parks and sports fields in built-up areas.

**Temminck's Coursers**[2] are migratory. They prefer open over-grazed and burnt grassland where they forage for insects and seeds.

**Crowned Lapwings**[3] are common and favour open areas and short grassland. They feed on insects, especially termites.

The resident population of **Bronze-winged Coursers**[4] is augmented in summer by a migratory population. They are largely nocturnal and feed on insects.

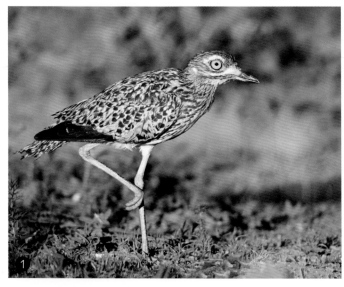

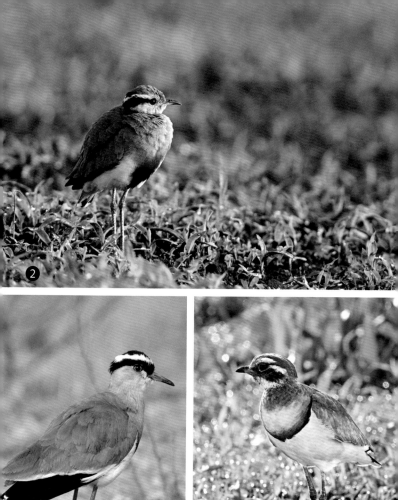

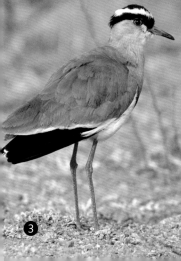

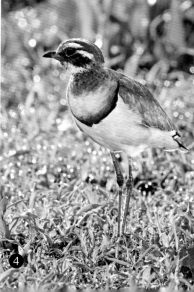

# Grassland larks

A huge area of southern Africa consists of grassland and semi-desert, and it is therefore not surprising many lark species make this their home. They are all cryptically coloured to blend in with their exposed habitat. They eat insects and seeds.

**Sabota Larks**[1] are widespread and common. They prefer open savanna where seeds form about 60% of their diet, and invertebrates the rest.

**Dusky Larks**[2] are non-breeding intra-African migrants visiting the northern part of the region. They are mainly insectivorous.

The clear, loud call of the **Rufous-naped Lark**[3] is a typical summer sound in open areas. These common residents feed on insects and seeds.

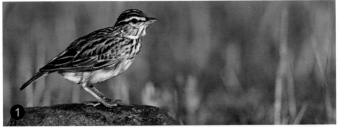

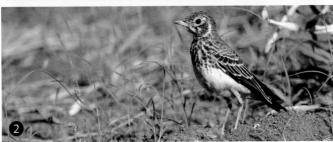

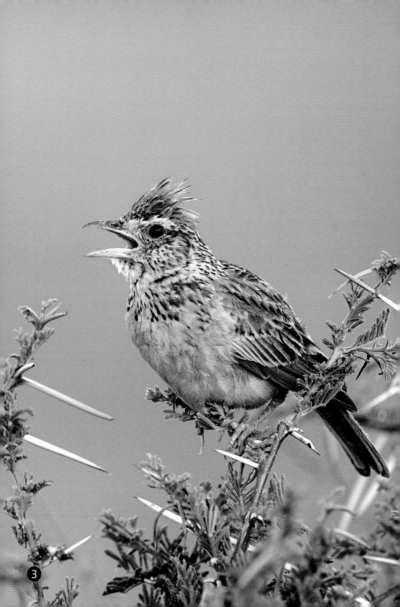

# Other grassland favourites

Pipits and longclaws are also birds of grassy habitats.
Pipits are extremely hard to identify as they look similar to
longclaws, except for the splash of colour which the latter
has on its breast.

**African Pipits**[1] are common residents. They feed primarily on insects.
  **Yellow-throated Longclaws**[2] favour areas with shortish grass, in
which they forage for insects. They have a clear, loud call, usually
from a perch in a tree.

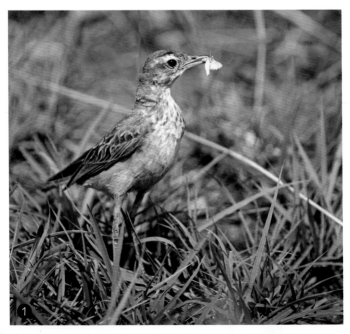

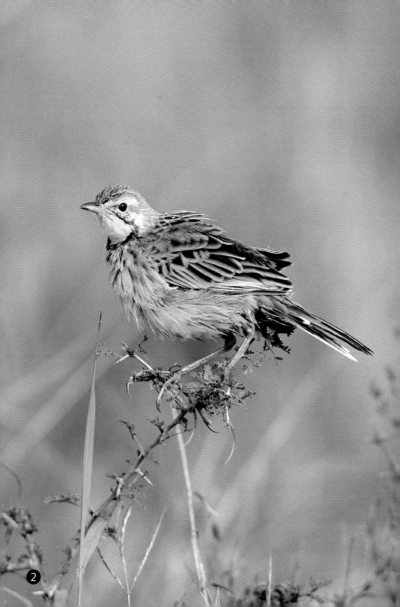

# Wild chickens

Francolins, spurfowls and guineafowls are domestic poultry-like birds that do all their foraging on the ground. They are reluctant to fly and sustain flight only for a short distance.

**Natal Spurfowls**[1] are common bushveld birds occurring in a variety of habitats. They are plant eating but supplement their diet in summer with insects.

    **Swainson's Spurfowls**[2] are common and widespread. They call regularly from a perch at dawn and dusk. They eat a variety of plant matter with more insects in summer.

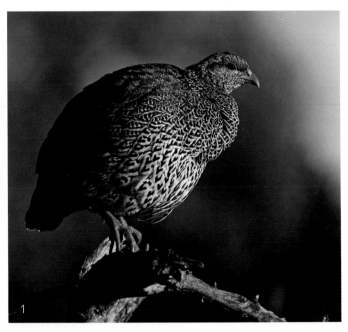

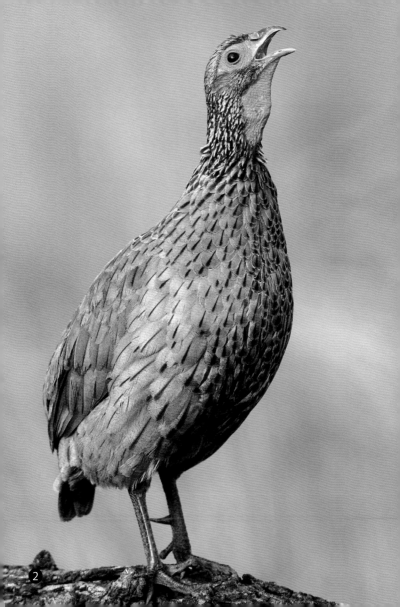

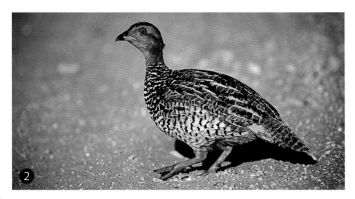

**Crested Francolins**[1] are true bushveld birds, favouring dense, bushy vegetation. Their duet call early in the morning and late afternoon is a typical bushveld sound.

    **Coqui Francolins**[2] like habitats with tall grass in the northern, wetter savanna region. They are the smallest of the southern African francolins.

    **Shelley's Francolins**[3] are fairly common and occur in open savanna. In winter they feed mostly on plants but in summer they increasingly take insects.

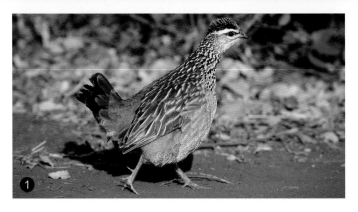

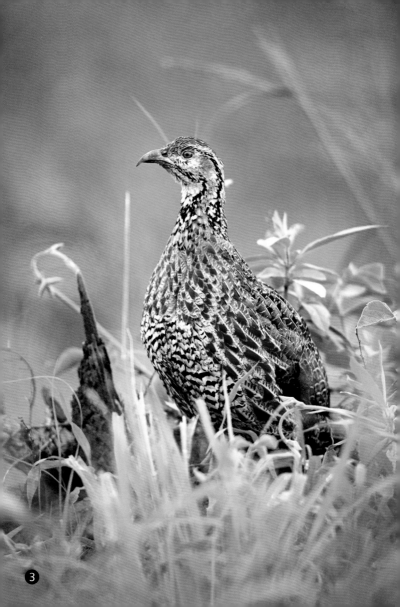

**Crested Guineafowls**[1] favour thicket and forest edges in well-wooded areas. They forage by sctratching in leaf litter and roost in groups in trees. Look out for them in the Pafuri area.

    **Helmeted Guineafowls**[2] are highly gregarious and are common over most of southern Africa. During the breeding season they usually form pairs.

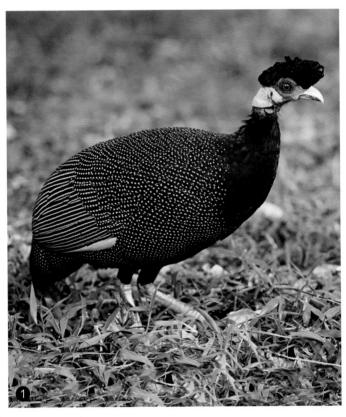

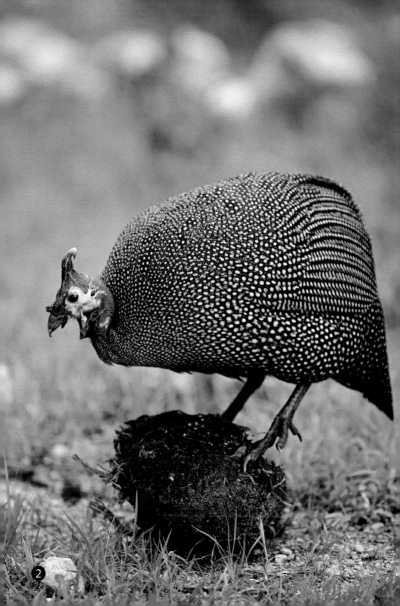

# Nightjars

Nightjars become active at dusk when they start hawking insects in flight, and are often seen on roads during night drives. Their plumage is extremely cryptic. During the day they roost on the ground, rocks or branches, relying on their camouflage to avoid being seen. They lay their eggs on the ground.

**Square-tailed Nightjars**[1] are common residents in the lowveld. They become active at dawn and hawk prey from the ground or a perch, but also in flight.

    **Fiery-necked Nightjars**[2] hawk insects from a perch. Their characteristic and distinctive call can be heard at dusk and dawn, and on moonlit nights.

    **European Nightjars**[3] are common and widespread non-breeding migrants to the region. They hawk insects at twilight and moonlight.

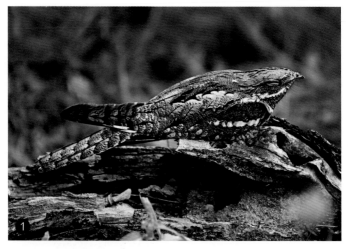

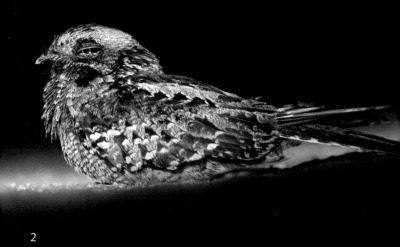

2

3

# BIRDS IN TREES

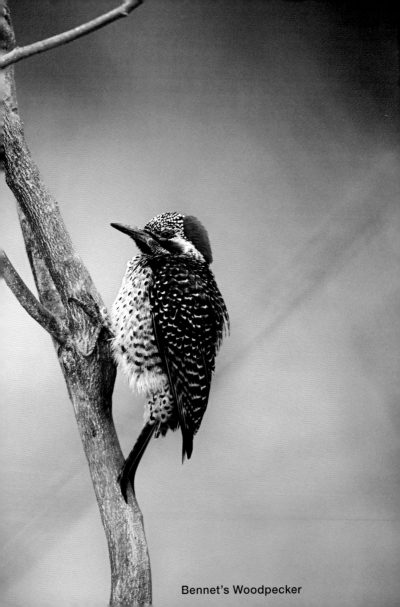
Bennet's Woodpecker

# BIRDS IN TREES

A vast area of southern Africa is clothed in bushes and trees, an area with the largest percentage of bird species. This diversity is possible because of the variety of different habitats offered. Many species use trees for nesting or as perches to catch prey, but a considerable number obtain most of their food in trees such as seeds, fruit, nectar, leaves or tree-living invertebrates and vertebrates.

## Barbets and Woodpeckers

Although barbets and woodpeckers chisel out their nests in dry tree trunks or branches and both have two forward-facing and two backward-facing toes, they do not belong to the same family and their biology is very different.

Barbets have large, thick, serrated bills. They are mainly fruit eating but also take insects and other smaller prey.

Woodpeckers fill a special niche in nature. They have strong, chisel-like bills to drill into dry wood to get to insects and borers and then use their long and mobile tongues to extract the prey. Some species feed on the ground.

The beautiful duet of a pair of **Black Collared Barbets** is a typical bushveld sound. They are to a large extent fruit-eating but do prey on insects.

**Acacia Pied Barbets**[1] are widespread and common in dry savanna areas. They feed on fruit, seeds and nectar, and will even feed on fat off bones.

**Crested Barbets**[2] often feed on the ground, looking for termites and other insects. Their call is a penetrating trill lasting up to 30 seconds.

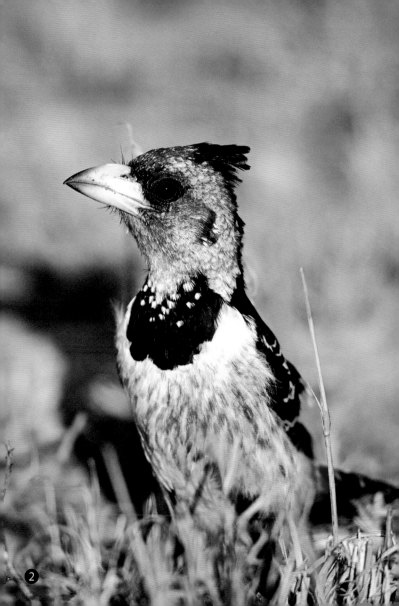

**Golden-tailed Woodpeckers**[1] are common residents in thornveld, woodland and even forests. They feed on insects, mainly ants and their larvae.

**Bennett's Woodpeckers**[2] often feed on the ground eating primarily ants, their eggs and pupae.

The widespread **Cardinal Woodpecker**[3] (see next spread) is a small bird with a brown forecrown in both sexes.

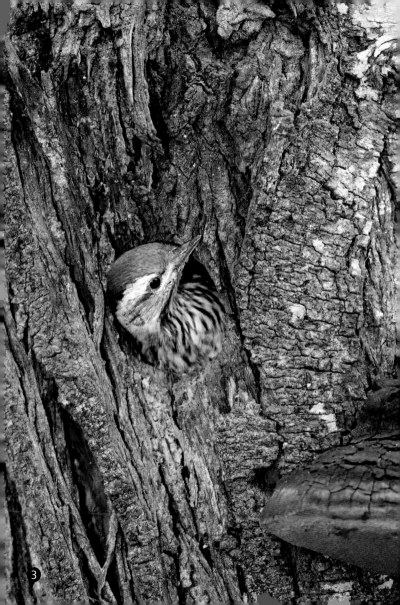

3

# Hornbills

All hornbills have huge, downward curving bills. They have a mixed diet including fruit, insects and vertebrates. During the breeding season the females of all species except the Southern Ground Hornbill are enclosed with mud and faeces in a natural tree cavity with a narrow slit left for feeding. Some time after the hatching of the fledglings, the entrance is opened and the female comes out, the cavity is closed again and both male and female feed the chicks until they can emerge.

**Southern Red-billed Hornbills**[1] prefer dry, open woodland in the northern part of the region. They mostly eat insects.

   **Southern Yellow-billed Hornbills**[2] are common and widespread and can often be seen in rest camps and picnic sites.

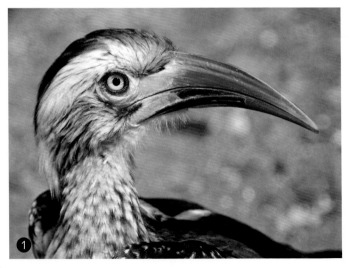

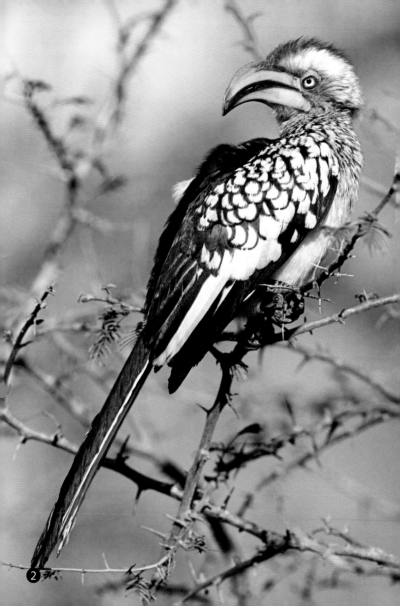

Look for **Trumpeter Hornbills**[1] in treetops where they feed on fruit, particularly figs.

**Crowned Hornbills**[2] feed mainly on fruit and prefer dense vegetation.

**African Grey Hornbills**[3] tend to forage in trees and are not often seen on the ground.

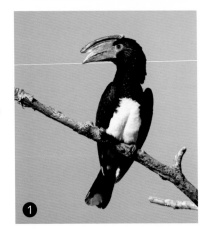

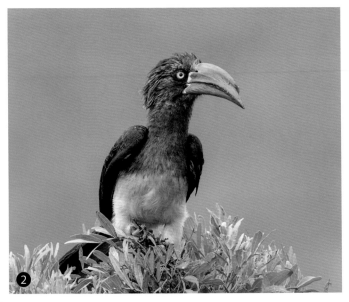

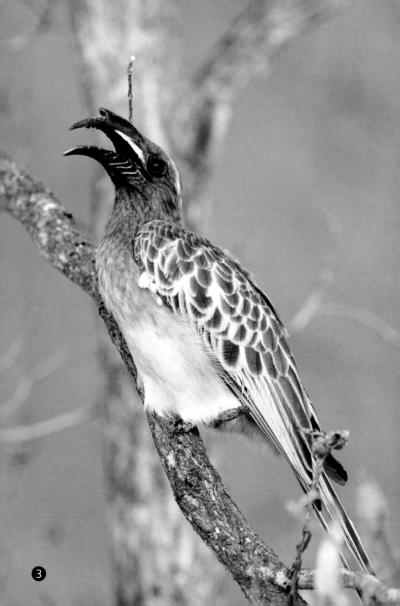

# Hoopoes and scimitarbills

Hoopoes and scimitarbills have long, slender, downward-curving bills suitable for probing for food. They feed mainly on insects and smaller vertebrae. The Wood-hoopoes and Common Scimitarbills also feed on nectar. They nest in natural cavities and holes, often in unused woodpecker and barbet nests.

**African Hoopoes**[1] are handsome birds that forage on the ground where they walk around actively probing the soil for prey.

**Green Wood-hoopoes**[2] are gregarious, noisy and active. They move about on trunks and branches where they probe holes, cracks and cavities for prey.

**Common Scimitarbills**[3] normally forage on their own, probing cavities for prey with their long, thin bills. They visit flowers for nectar.

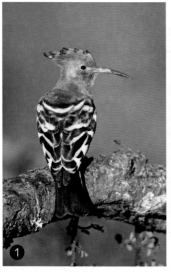

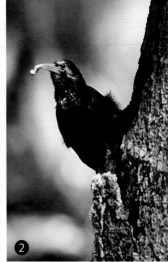

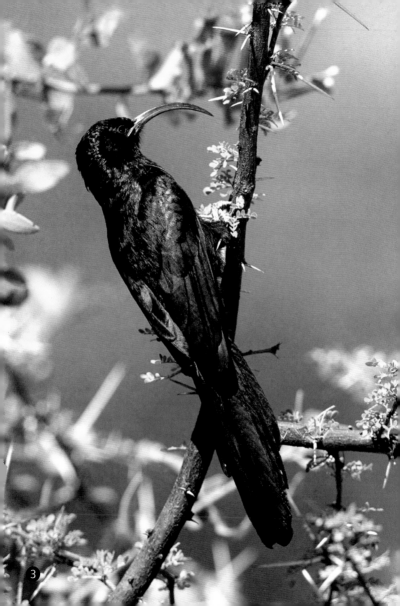

# The insect spies

Quite a number of bird species use trees as perches from where they scan their surroundings for prey. These include many of the raptors, rollers, bee-eaters, drongos, the non-aquatic kingfishers, some shrikes and flycatchers.

**Lilac-breasted Rollers** can be regarded as iconic birds of the bush-veld. Their bright, spectacular plumage can best be admired when they are in flight.

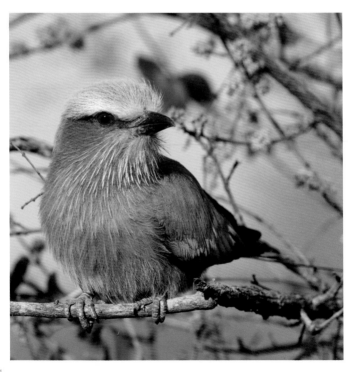

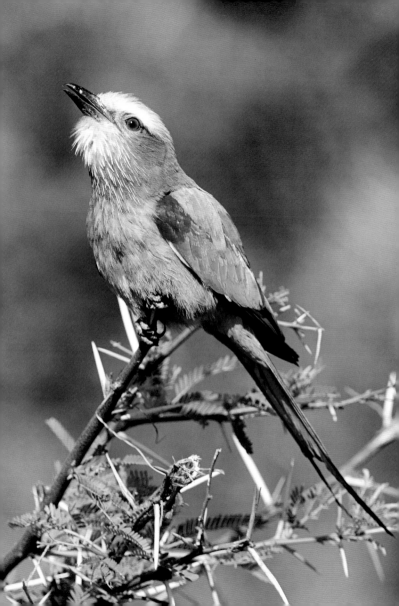

**Purple Rollers**[1] are not as common in the region. Their prey includes a large number of insects but bigger vertebrates such as birds and mice are also caught.

   **European Rollers**[2] are non-breeding migrants arriving in early summer in great numbers to benefit from the temporary explosion of insect numbers during the rainy season.

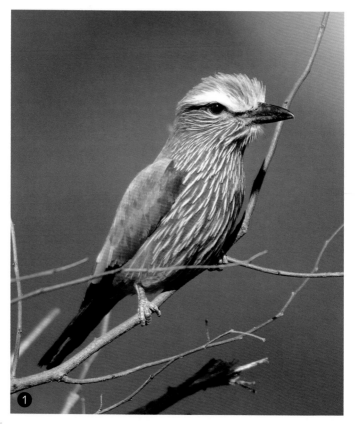

**European Bee-eaters**[1] are non-breeding summer visitors to Kruger all the way from Eurasia. They hunt while flying and their calls can often be heard before you can see them.

**Southern Carmine Bee-eaters**[2] are highly gregarious and flocks of hundreds of birds are common, especially in their breeding area. They breed to the north of South Africa and migrate southwards after breeding. They prey on large flying insects and they even feed on highly toxic blister beetles.

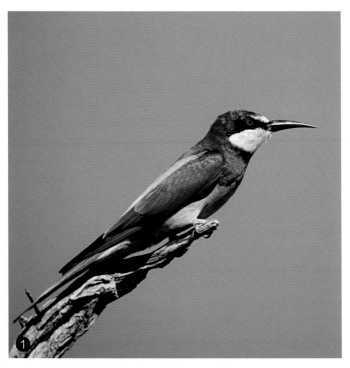

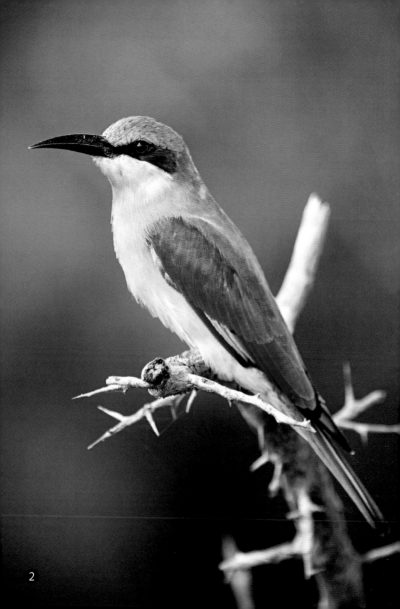

During the day **Little Bee-eaters**[1] hunt alone or in pairs but roost in groups in a tightly packed row on a branch at night.

   **White-fronted Bee-eaters**[2] are common widespread residents. Look for them along rivers in the bushveld and for their breeding holes in riverbanks. They hunt from a perch and catch flying insects in the air or on the surface of water.

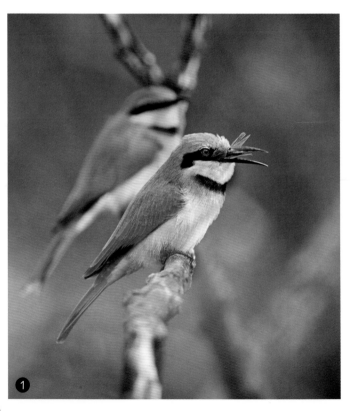

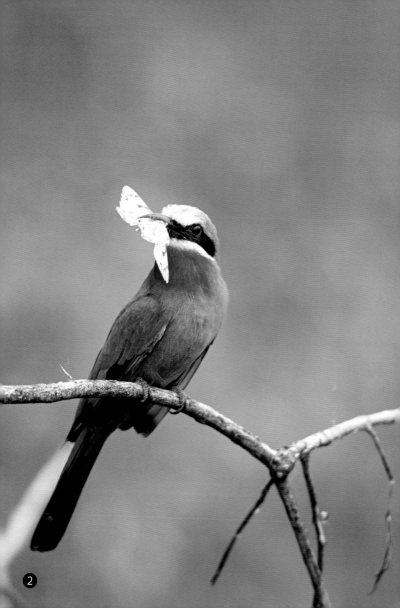

The aggressive and bold **Fork-tailed Drongo** is common and widespread. It feeds on a variety of food items including insects, smaller vertebrates, ticks as well as nectar. It often accompanies grazing animals to catch the insects they disturb in the grass, and it also robs other insect-eaters of their prey.

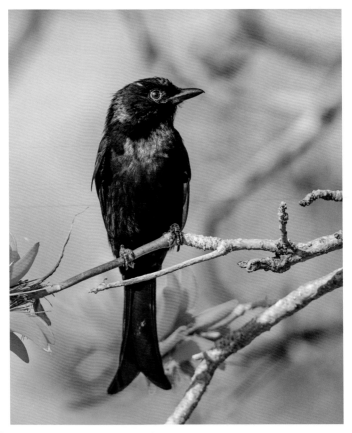

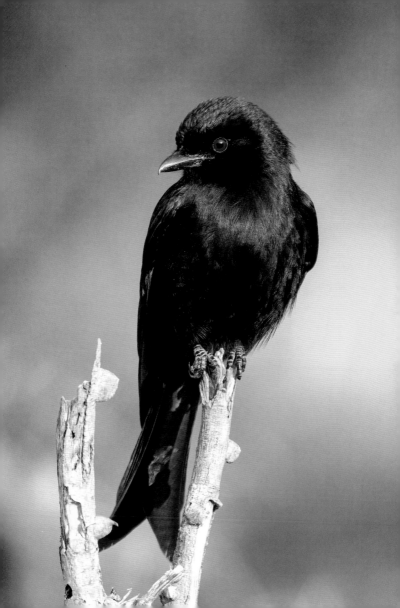

The **African Pygmy Kingfisher**[1] is a breeding intra-African visitor which migrates at night. It prefers habitats with denser vegetation.

  **Woodland Kingfishers**[2] are common breeding visitors. They are highly vocal and their call is a characteristic sound of the bushveld during summer. They perch low down in trees, scanning the ground for prey.

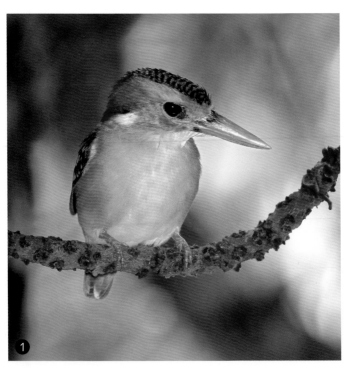

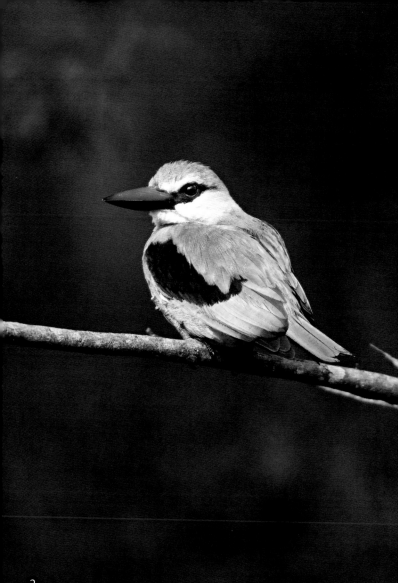

The **Striped Kingfisher**[1] is common and widespread, especially where there are large trees. It is a small kingfisher, unobtrusive when not calling and feeds on insects and small reptiles.

    **Brown-hooded Kingfishers**[2] are common residents in all woodland types, as well as gardens and parks. They feed on insects and smaller vertebrates, including small birds.

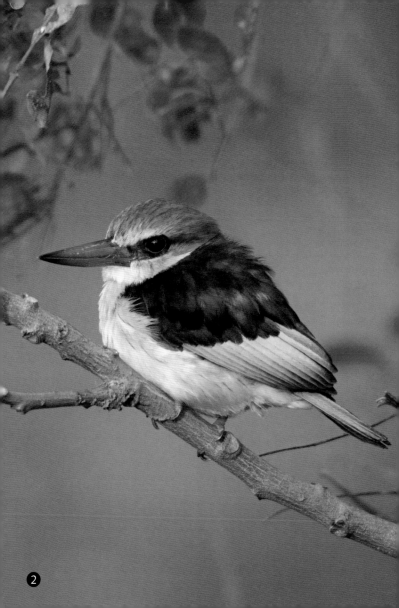

**Lesser Grey Shrikes**[1] are summer visitors from Europe and Asia that do not breed in Africa. They prefer dry, open areas. Like the Common Fiscal, they impale prey on thorns.

**Southern White-crowned Shrikes**[2] prefer open woodland. They perch conspicuously in groups or solitary in trees from where they look out for insects.

The **Common Fiscal**[3] is widespread and common in open areas with scattered trees and shrubs. Like the Lesser Grey, it also impales its prey on thorns and for that reason, one of its common names is Jackie Hangman.

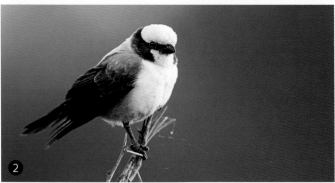

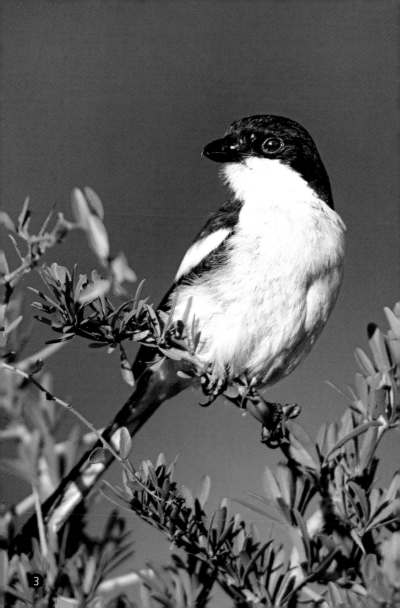

**Magpie Shrikes**[1] hunt in small groups by perching low and catching prey on the ground.

   **Red-backed Shrikes**[2] are common non-breeding summer visitors to open savanna. They are specialist insect catchers.

❷

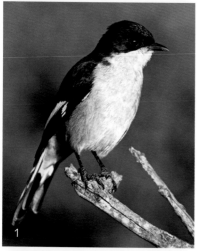

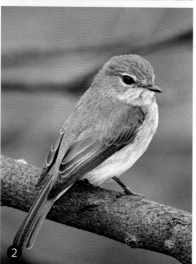

**Fiscal Flycatchers**[1] look very similar to the Common Fiscal.

**Ashy Flycatchers**[2] are confined to the eastern region of southern Africa. They use a low perch to hawk insects in flight.

**African Paradise Flycatchers**[3] are breeding migrants to denser bush-veld areas. Some remain all year round in the lower, eastern regions. The male has an exquisite orange-rust tail twice the body length.

**Spotted Flycatchers**[4] are common non-breeding migrants from the northern hemisphere. They feed mainly on in-sects caught in flight and occasionally small fruit.

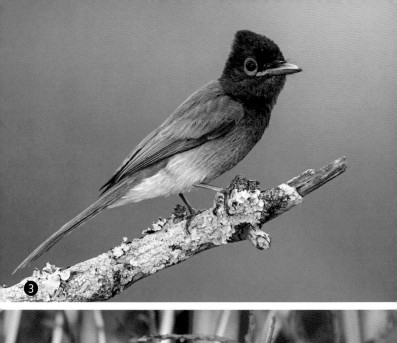

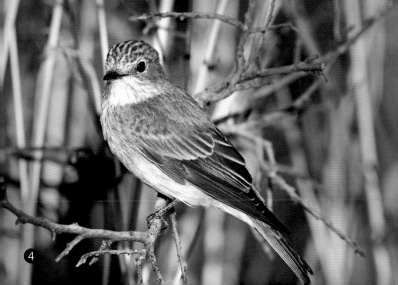

# The fruit eaters

Many bird species forage in trees for tree-living organisms, plant material and fruit. Carnivorous species go from tree to tree looking for suitable prey, and the fruit-eaters concentrate on trees with ripening fruit. There are, however, many species that feed on both animal and plant matter.

Most pigeons are seed-eaters but some species are primarily fruit eating. Of these, the African Green Pigeon is the most likely to be seen on game drives. **African Green Pigeons**[1] prefer dense vegetation with fruiting trees, especially wild figs. They gather in small numbers at a suitable food source.

    **Grey Go-away-birds**[2] (see next spread) are common in dry savanna areas where their highly vocal call is a well-known sound. They feed on fruit, buds, flowers, nectar and invertebrates.

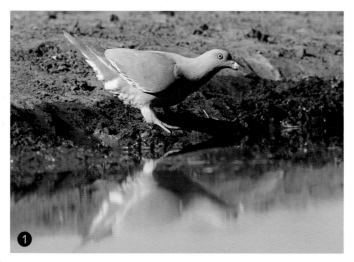

1

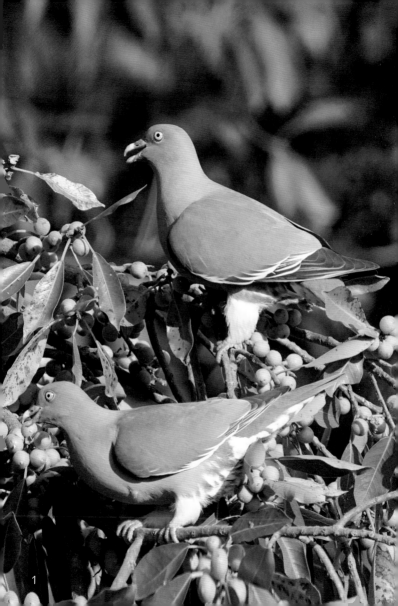

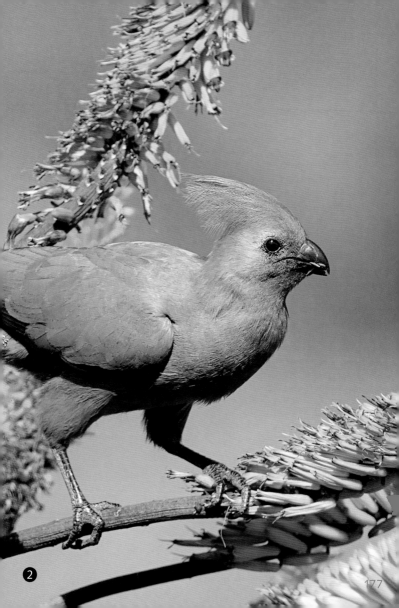

2

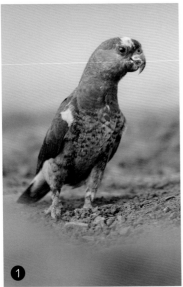

Meyer's Parrots[1] favour dry savanna woodland where they feed on fruit and fruit kernels, nuts, seeds and flowers.

**Brown-headed Parrots**[2] are common in Kruger. They feed on fruit, seeds, flowers, leaves and nectar.

**Purple-crested Turacos**[3] are beautiful birds that prefer dense woodland and riparian bush where they feed on fruit and leaf buds. The bright red primary feathers can best be seen when they are in flight.

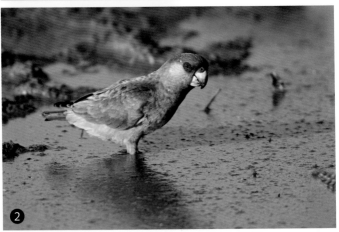

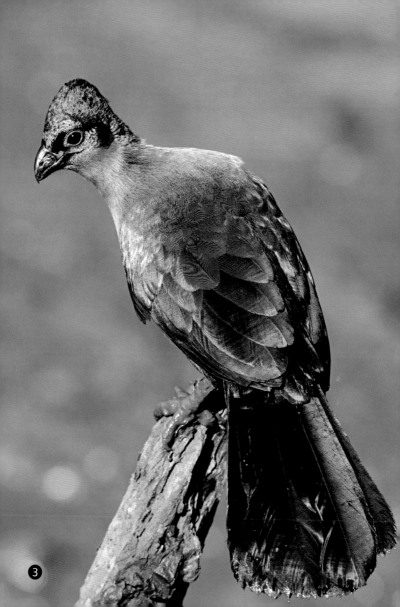

**Red-faced Mousebirds**[1] are widespread in Africa and occur in gardens. Their diet consists mainly of fruit but they also eat leaves, flowers and nectar.

**Speckled Mousebirds**[2] occur in the eastern bushveld regions. They feed on fruit, leaves and nectar but will take insects such as winged termites.

# The everything eaters

Omnivorous birds make up the bulk of arboreal birds. As a result of their diverse diet, they are more adaptable and therefore occur in larger numbers – some of the most common birds are in this group.

The common endemic **Cape White-eye**[1] occurs in most wooded habitats. They forage restlessly in small groups in trees for small insects and fruit but also join sunbirds to feed on nectar.

    **Sombre Greenbuls**[2] prefer dense thicket where they are more often heard than seen. They forage at all levels of the vegetation for fruit, insects, leaf buds and snails. They visit aloe flowers for nectar.

    **Dark-capped Bulbuls**[3] are abundant in Kruger. They have a cosmopolitan diet consisting of fruit, flowers, insects, small vertebrates and nectar.

    **Black-headed Orioles**[4] (see next spread) normally forage for insects and fruit in the top of trees from where they call their melodious notes. When aloes are in flower they come down to feed on nectar and are more easily seen.

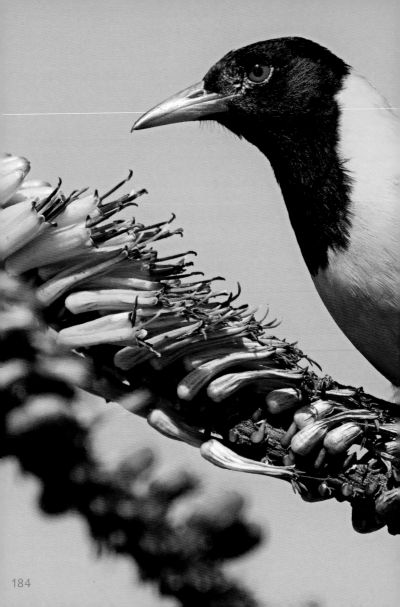

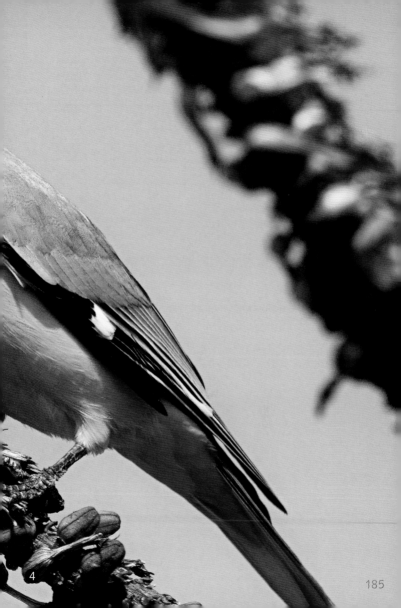

4

**Spectacled Weavers**[1] forage by creeping in trees and shrubs. They form pairs and do not change plumage during the breeding season. Their food consists of invertebrates, fruit, seeds and nectar.

**Red-headed Weavers**[2] forage off plant surfaces for insects, spiders, seeds and fruit. They build untidy nests of twigs, sticks and leaves.

**1**

**Red-winged Starlings**[1] prefer rocky areas. They forage in trees or on the ground. Their food consists of fruit, insects, ectoparasites, lizards and aloe nectar.

**Greater Blue-eared Starlings**[2] are fruit- and insect eaters. They sometimes form large flocks.

**Meve's Starlings**[3] are common in northern woodland regions with mopane and baobab, and can regularly be seen in the Pafuri area. They roost in large flocks.

When not breeding **Cape Glossy Starlings**[4] move in small flocks. They feed in trees and on the ground. They eat fruit, insects and nectar.

**Burchell's Starlings**[5] occur in open acacia savanna. They forage on bare ground for insects and smaller vertebrates or look for fruit in trees.

**Wattled Starlings**[1] are gregarious birds and nomadic, moving from one suitable food source to another. They feed on fruit, nectar and invertebrates.

**Violet-backed Starlings**[2] are breeding intra-African migrants. They forage mainly in trees for fruit and insects, but also hawk flying insects.

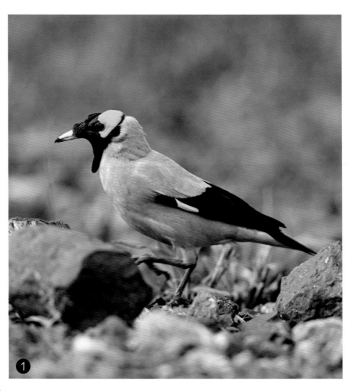

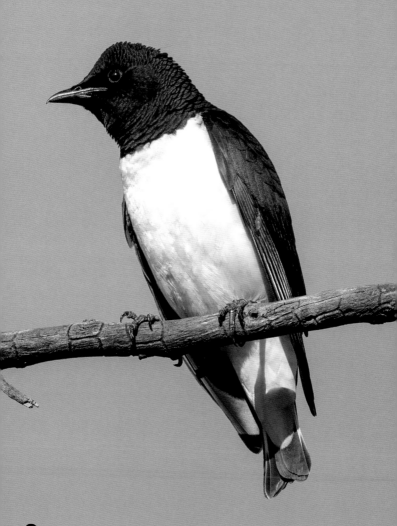

2

**Pied Crows**[1] can sometimes be seen at carcasses and road kills, and they often visit dumpsites. They are, however, also plant-eaters and catch a variety of animals.

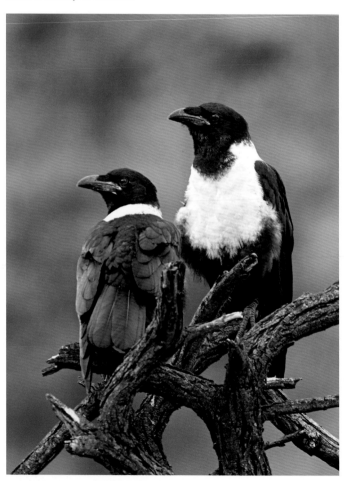

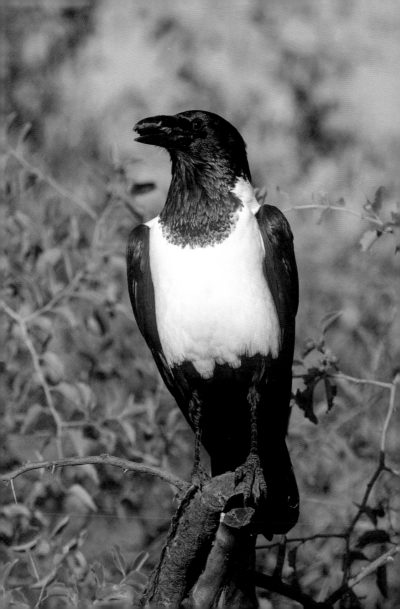

# Carnivorous foragers

The great majority of tree-living (arboreal) birds feed on smaller prey items such as insects, spiders, worms and smaller vertebrates. They feed either by moving around in trees and shrubs, or by foraging on the ground.

**Brubrus**[1] usually forage for insects high in trees. They are more often heard than seen.

The highly vocal **Rattling Cisticola's**[2] call must be one of the most characteristic sounds of the bushveld. They are insectivorous.

**Long-billed Crombecs**[3] have short tails. They forage for insects on trunks, leaves and branches, working their way up from the bottom to the top.

**Chin-spot Batisses**[4] are common residents and can often be seen foraging in pairs in trees. The name is derived from the chestnut chin spot of the female.

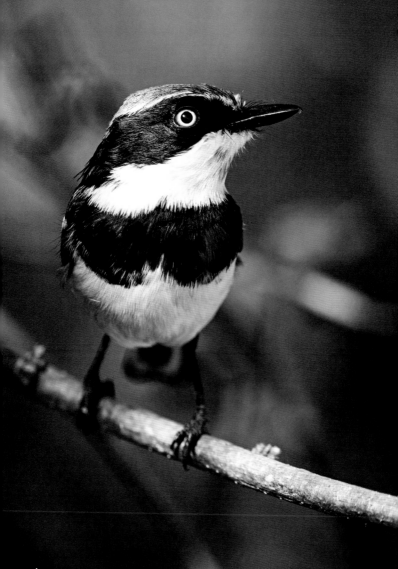

**White-crested Helmet-shrikes**[1] are gregarious. They forage in groups for insects, spiders and small vertebrates at all levels and on the ground.

Although **Orange-breasted Bush-shrikes**[2] are very vocal, they are not easy to see. They forage for their insect prey in the woodland canopy.

**Grey-headed Bush-shrikes**[3] have a varied diet ranging from insects to reptiles, birds and mammals. They wedge larger prey in a tree fork and then dismember it with their heavy bills.

3

**Black-backed Puffbacks**[1] forage higher up in trees where they glean insects from trunks, branches and leaves. Males have a spectacular display, raising their white back feathers to create a puff.

**Black-crowned Tchagras**[2] are common in savanna areas. They feed on insects and smaller reptiles.

**Southern Boubous**[3] are vocal and pairs keep in contact by duetting. They feed on insects, birds' eggs, fledglings, reptiles, smaller mammals and even fruit.

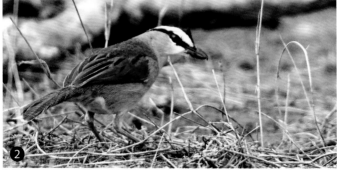

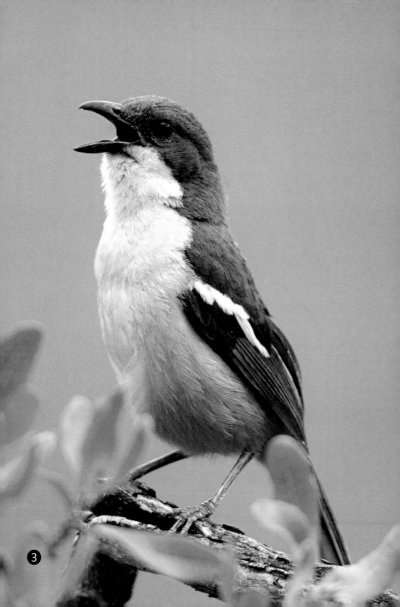

❸

The **Diderick Cuckoo**[1] is the most common of the three green
cuckoos. They are intra-African migrants and leave eggs in the
nests of bishops, weavers and sparrows.

The **Jacobin Cuckoo**'s[2] loud call can be heard from October to
May. They parasitise bulbuls and Common Fiscals.

**Great Spotted Cuckoos**[3] are summer visitors to the region. They
are conspicuous and noisy. Prey consists mainly of hairy caterpil-
lars. They use crows and starlings as hosts.

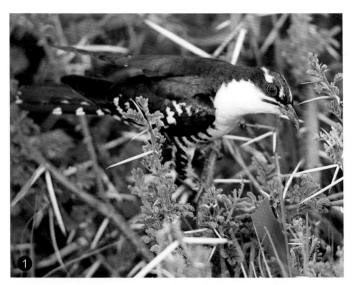

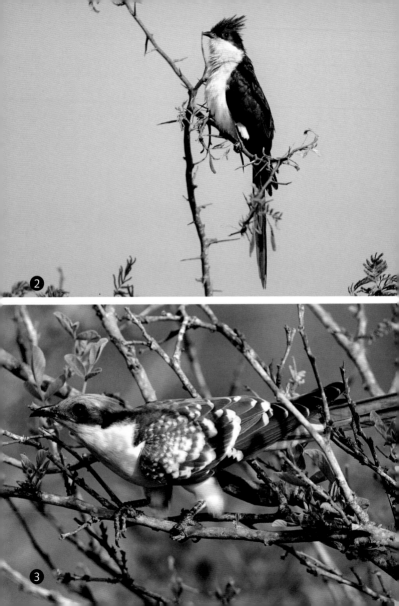

**Red-capped Robin-Chats**[1] prefer dense vegetation along rivers and round dams. They are excellent songsters and impressive mimics artist.

The **White-browed Robin-Chat**[2] can be regarded as one of the best avian songsters in the world. It forages mainly on the ground during the early morning and late afternoon.

**White-throated Robin-Chats**[3] favour thicket in the eastern savanna region. They feed on insects and occasionally fruit.

**Mocking Cliff Chats**[4] occur in rocky terrain in the savanna. They feed on insects, fruit and aloe nectar.

**Arrow-marked Babblers** live in close-knit family groups. They forage on the ground for a variety of invertebrates and vertebrates.

**Kurrichane Thrushes**[1] are found in the eastern bushveld areas and are also common in rest camps. They feed on insects, worms, spiders and small reptiles. They expose prey by tossing leaves aside.

**Groundscraper Thrushes**[2] forage in open areas, including lawns in parks and gardens. Their food consists largely of insects and earthworms.

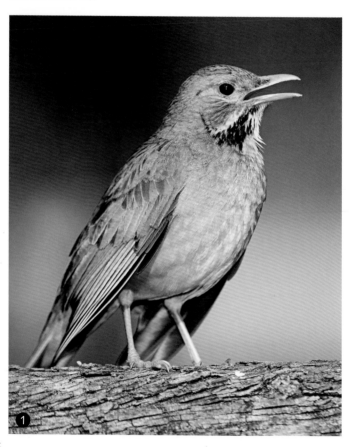

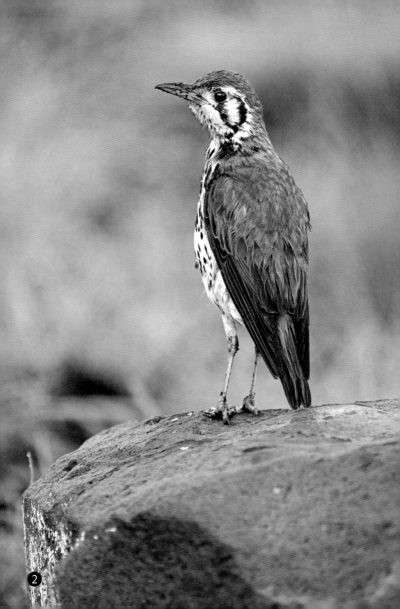

Burchell's Coucals favour riparian vegetation with long grass. They like to sun themselves on an exposed perch in the morning, and feed on a wide range of vertebrates and invertebrates.

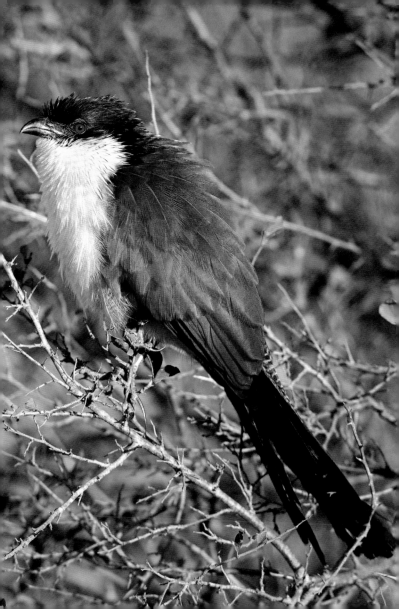

# Oxpeckers

Oxpeckers spend most of their time on larger mammals feeding on ectoparasites such as ticks and insects, loose skin and even blood of the host animal. They do, however, roost in trees and often nest in holes in trees.

**Yellow-billed Oxpeckers**[1] prefer to forage on large mammals, and can often be seen on buffaloes.

**Red-billed Oxpeckers**[2] are more common and widespread in bushveld areas. They occur in small groups and use giraffe, antelope, buffalo, zebra and even domestic cattle as hosts.

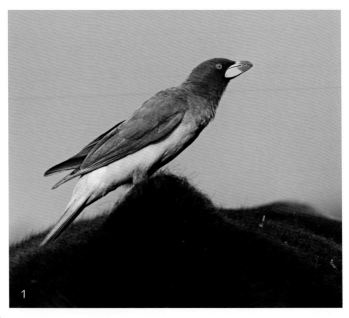

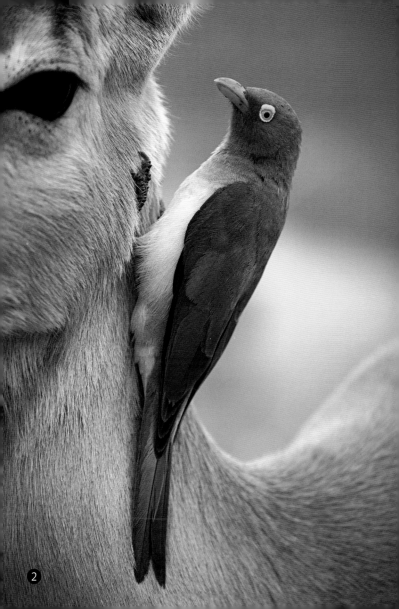

# Swallows

Swallows are diurnal hunters of flying insects. They have small, flattened bills which can open very wide. Their slender, streamlined bodies and long, pointed wings allow them to stay in the air for long periods, hawking insects. Many are migratory. Although their food is obtained while flying, they often rest and roost in trees.

**Red-breasted Swallows**[1] are locally common breeding intra-African migrants from tropical Africa.

    **Barn (European) Swallows**[2] are by far the most common swallow in summer. At night they roost in large numbers in reed beds. They are migrants that breed in the northern hemisphere.

    **Lesser Striped Swallows**[3] are common breeding migrants in the eastern low-lying region. They are mainly insectivorous but also eat fruit and small seeds.

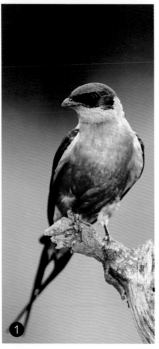

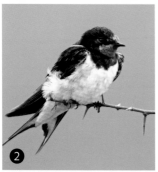

# The seed crackers

Seedeaters are found throughout southern Africa in all habitats. Grasslands come to mind when considering seedeaters but even some plants on the forest floor provide seeds for them. Although they spend a lot of time feeding on the ground, they roost and nest in trees and shrubs. Many of the smaller birds have short conical bills adapted for cracking open seeds. Most of the species nest in trees, shrubs, tall grass and reeds, but the greater part of their food is obtained on the ground. As seedeaters they have to drink regularly, and waiting at drinking places is recommended if you want to observe these birds, especially the small, unobtrusive species.

In summer the male **White-winged Widowbird**[1] displays from an exposed perch or by flying slowly. They occur in vlei areas with rank vegetation.

**Southern Red Bishops**[2] are not common in Kruger. They nest in colonies, in reed beds in or on the edge of water.

**Southern Masked-weavers**[1] are widespread and common in open savanna and also in rest camps. They are gregarious when feeding and breed in colonies, but sometimes a solitary male builds a number of nests.

**Village Weavers**[2] are common in the eastern savanna regions. They are gregarious and breed in colonies in trees and reeds.

**Red-billed Buffalo-weavers**[3] build huge, untidy nests with thorny twigs. They form small flocks and forage on the ground for seeds, fruit and insects.

**Lesser Masked-weavers**[4] are gregarious in small flocks at all times and breed in colonies in trees, often over water. They feed on insects, seeds and nectar.

**Red-billed Queleas**[5] are abundant and flocks can number hundreds of thousands. After good rain in an area, they build an enormous number of nests there.

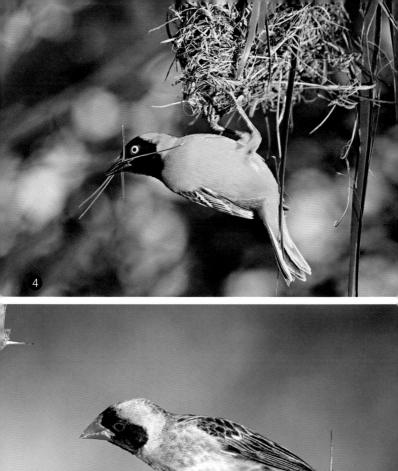

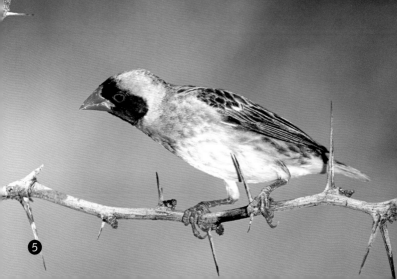

**Red-billed Firefinches**[1] favour acacia savanna where they can be seen feeding on the ground in clearings and on road verges. They eat seed but also take some insects.

**Blue Waxbills**[2] are common in eastern bushveld regions. They forage in small flocks on the ground for seeds and insects, and regularly visit waterholes.

**Violet-eared Waxbills**[3] occur in dry savanna. They are often seen at waterholes where they gather with other seedeaters to drink.

**Green-winged Pytillias**[4] forage in pairs or small flocks in clearings for seeds and insects. They are not easily seen but look for them at a drinking place as they drink regularly.

**Common Waxbills**[5] are gregarious and prefer rank vegetation. They forage on the ground for seeds and insects, or in trees for fruit.

**Jameson's Firefinch**[6] is a common resident in the eastern savanna regions where it favours rank vegetation, feeding on seeds and small insects.

Shaft-tailed Whydahs[1] favour dry acacia savanna. They generally use Violet-eared Waxbills as hosts.

Breeding **Pin-tailed Whydah**[2] males are extremely aggressive towards all other birds at a feeding place. They use waxbills as hosts to rear their young.

**Southern Grey-headed Sparrows**[1] are widespread in dry savanna areas and often enter human settlements.

**Red-headed Finches**[2] are highly nomadic and gregarious when not breeding.

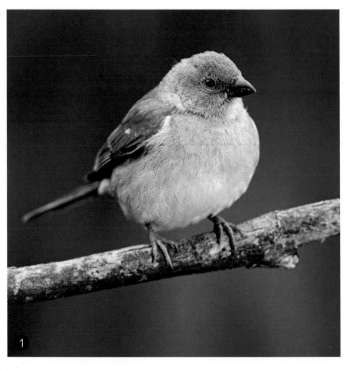

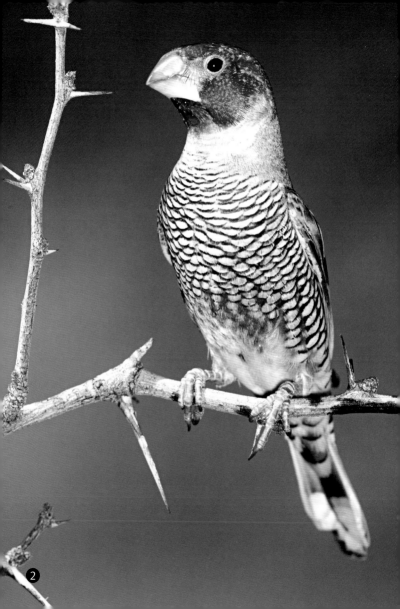

Yellow-fronted Canaries[1] are common in throughout Kruger.

Brimstone Canaries[2] occur in the eastern montane and coastal areas. They do eat seeds but include more fruit in their diet.

Golden-breasted Buntings[3] occur in bushveld, riverine bush and also in gardens. They feed on insects, seeds and buds.

Cinnamon-breasted Buntings[4] favour rocky and broken terrain. They feed on the ground, eating seeds as well as some insects.

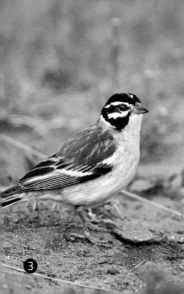

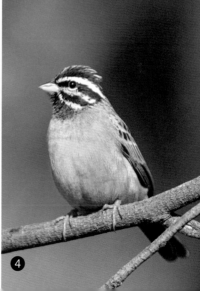

# The soft-billed seedeaters

In southern Africa some species of doves and pigeons are quite common. Most feed on the ground looking for seeds. Not having the seed-cracking bills of other seedeaters, they ingest small stones to assist digestion.

**Namaqua Doves**[1] are birds of the dry bushveld. They feed on small seeds.

**Laughing Doves**[2] are abundant and widespread. They feed on seeds and occasionally fruit and insects.

**Cape Turtle Doves**[3] have a wide distribution and are common, especially in the drier areas.

**Emerald-spotted Wood-doves**[4] are real bushveld birds occurring in the eastern region. They feed on seeds but also fruit and insects.

**African Mourning Doves**[5] are seed-eating and have a smaller distribution than the other two turtle doves.

**Red-eyed Doves**[6] prefer well-developed woodland. They feed on seeds and small fruit.

**Speckled Pigeons**[7] breed on rock ledges.

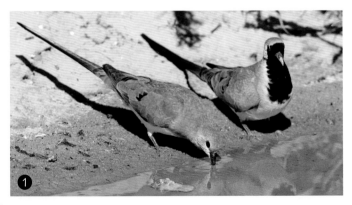

1

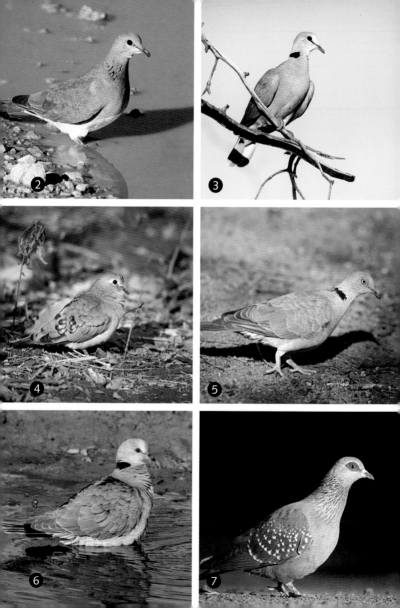

# Sunbirds

When considering nectar as a food item, sunbirds and sugarbirds come to mind. There are, however, many other insect- and seed-eating birds that will relish a good source of nectar, especially from aloes. Sunbirds are small nectar-feeding birds with long, down-curved bills and long extendable tongues. The males are brightly coloured with a metallic green or bronze sheen, and the females are dull and difficult to identify. They are active and feed mainly on nectar, but fruit and some arthropods are also eaten.

**Amethyst Sunbirds**[1] are restless and aggressive, and often hover to extract nectar.

**Collared Sunbirds**[2] are small, and both the male and female are brightly coloured. The male can be distinguished by its green and blue throat. They include small fruit in their diet.

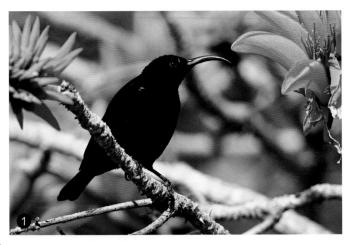

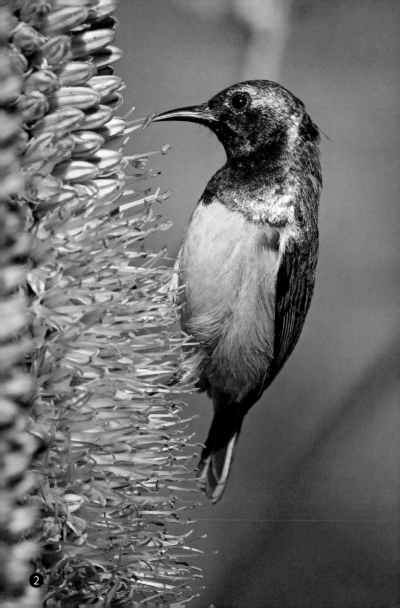

The sooty black **Scarlet-chested Sunbird**[1] male often sings from a conspicuous perch high in a tree. These sunbirds feed on spiders, insects and nectar, especially of aloe and coral tree flowers.

**White-bellied Sunbirds**[2] are also small and occur in acacia savanna and drier woodland. They feed on nectar of many plants and are common visitors to flowering aloes.

**Marico Sunbirds**[3] are common and widespread in acacia savanna, riverine bush and rest camps. The males are restless and aggressive.

**Purple-banded Sunbirds**[4] look very much like Marico Sunbirds but are smaller with a narrower breast band and shorter bill.

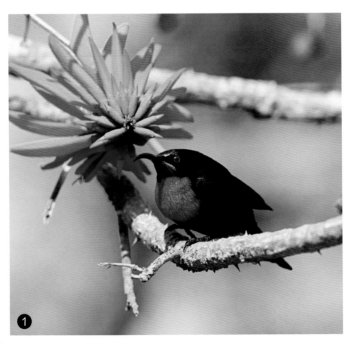

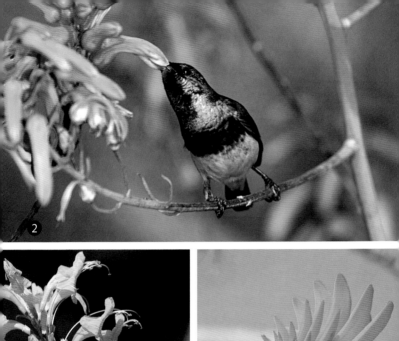

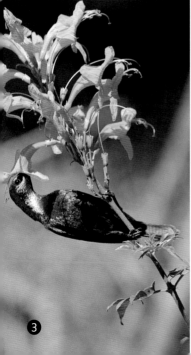

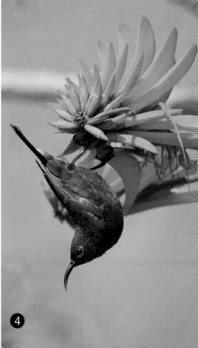

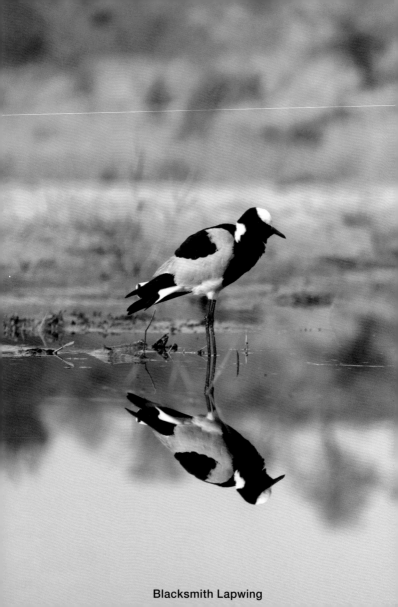

Blacksmith Lapwing

# THUMBNAILS
## of Kruger birds

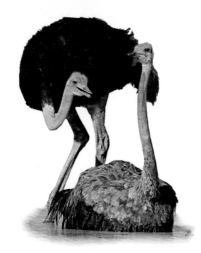

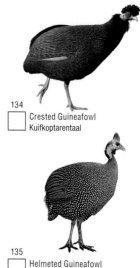

134
Crested Guineafowl
Kuifkoptarentaal

135
Helmeted Guineafowl
Gewone Tarentaal

112
Common Ostrich
Volstruis

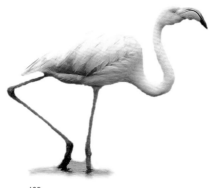

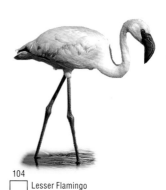

105
Greater Flamingo
Grootflamink

104
Lesser Flamingo
Kleinflamink

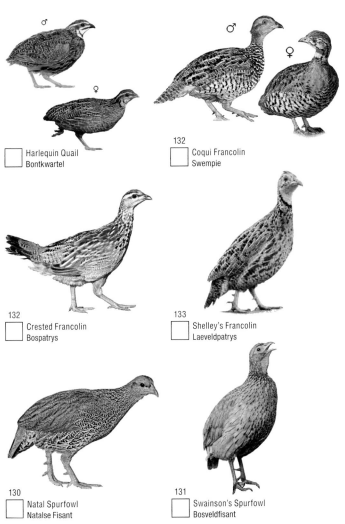

♂

♀

☐ Harlequin Quail
Bontkwartel

♂

♀

132
☐ Coqui Francolin
Swempie

132
☐ Crested Francolin
Bospatrys

133
☐ Shelley's Francolin
Laeveldpatrys

130
☐ Natal Spurfowl
Natalse Fisant

131
☐ Swainson's Spurfowl
Bosveldfisant

235

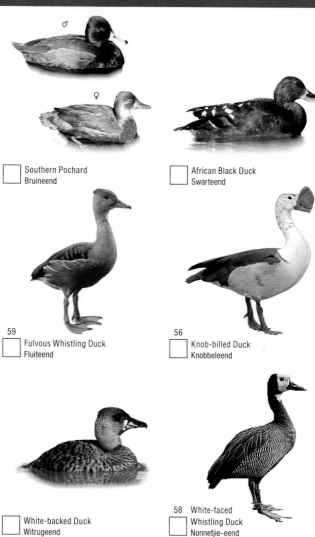

Southern Pochard
Bruineend

African Black Duck
Swarteend

59 Fulvous Whistling Duck
Fluiteend

56 Knob-billed Duck
Knobbeleend

White-backed Duck
Witrugeend

58 White-faced
Whistling Duck
Nonnetjie-eend

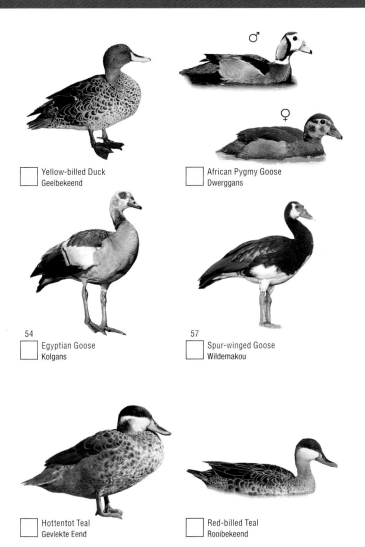

☐ Yellow-billed Duck
Geelbekeend

♂

♀

☐ African Pygmy Goose
Dwerggans

54
☐ Egyptian Goose
Kolgans

57
☐ Spur-winged Goose
Wildemakou

☐ Hottentot Teal
Gevlekte Eend

☐ Red-billed Teal
Rooibekeend

237

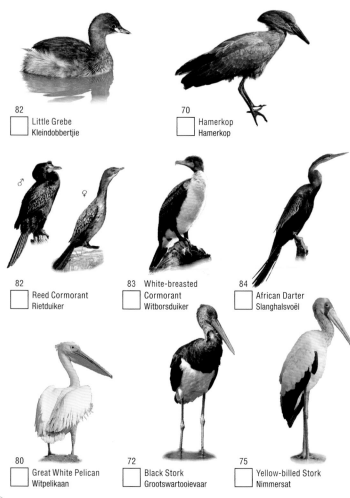

82
[ ] Little Grebe
Kleindobbertjie

70
[ ] Hamerkop
Hamerkop

82
[ ] Reed Cormorant
Rietduiker

83 White-breasted
[ ] Cormorant
Witborsduiker

84
[ ] African Darter
Slanghalsvoël

80
[ ] Great White Pelican
Witpelikaan

72
[ ] Black Stork
Grootswartooievaar

75
[ ] Yellow-billed Stork
Nimmersat

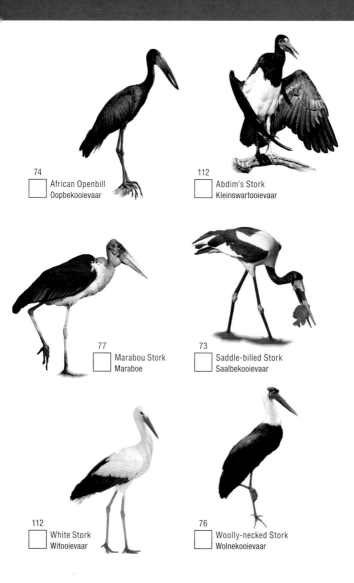

74
☐ African Openbill
Oopbekooievaar

112
☐ Abdim's Stork
Kleinswartooievaar

77
☐ Marabou Stork
Maraboe

73
☐ Saddle-billed Stork
Saalbekooievaar

112
☐ White Stork
Witooievaar

76
☐ Woolly-necked Stork
Wolnekooievaar

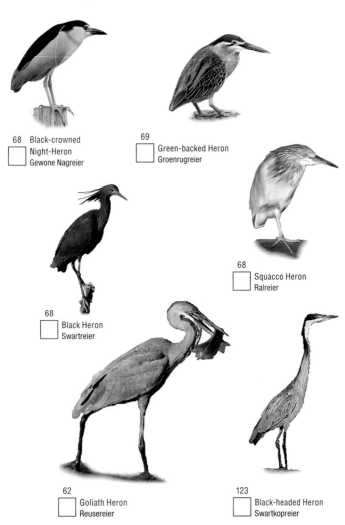

68 Black-crowned
Night-Heron
Gewone Nagreier

69 Green-backed Heron
Groenrugreier

68 Squacco Heron
Ralreier

68 Black Heron
Swartreier

62 Goliath Heron
Reusereier

123 Black-headed Heron
Swartkopreier

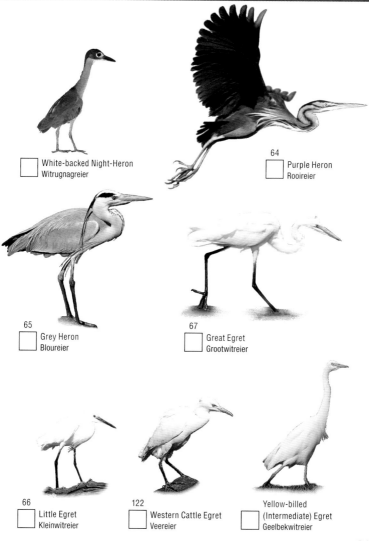

White-backed Night-Heron
Witrugnagreier

64 Purple Heron
Rooireier

65 Grey Heron
Bloureier

67 Great Egret
Grootwitreier

66 Little Egret
Kleinwitreier

122 Western Cattle Egret
Veereier

Yellow-billed
(Intermediate) Egret
Geelbekwitreier

241

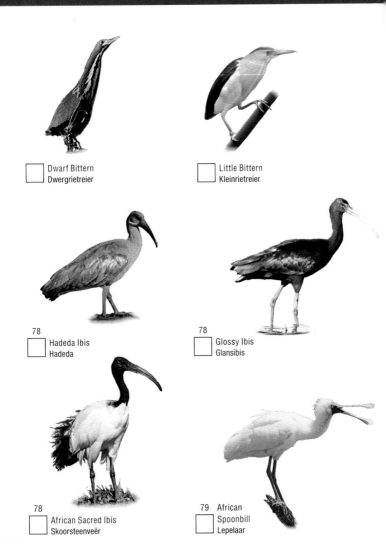

☐ Dwarf Bittern
Dwergrietreier

☐ Little Bittern
Kleinrietreier

78
☐ Hadeda Ibis
Hadeda

78
☐ Glossy Ibis
Glansibis

78
☐ African Sacred Ibis
Skoorsteenveër

79 African
☐ Spoonbill
Lepelaar

242

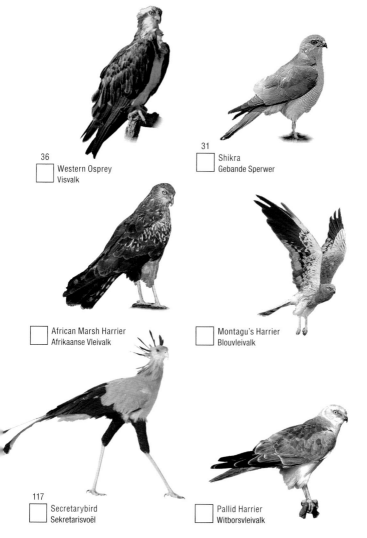

36
Western Osprey
Visvalk

31
Shikra
Gebande Sperwer

African Marsh Harrier
Afrikaanse Vleivalk

Montagu's Harrier
Blouvleivalk

117
Secretarybird
Sekretarisvoël

Pallid Harrier
Witborsvleivalk

243

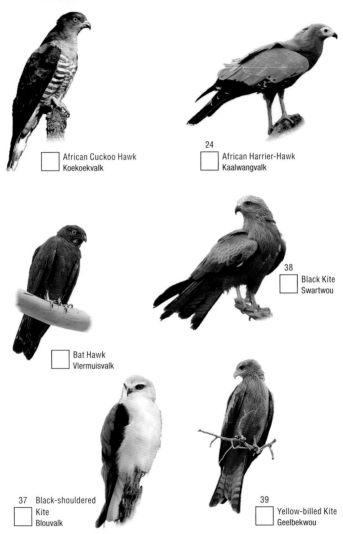

☐ African Cuckoo Hawk
Koekoekvalk

24 ☐ African Harrier-Hawk
Kaalwangvalk

☐ Bat Hawk
Vlermuisvalk

38 ☐ Black Kite
Swartwou

37 ☐ Black-shouldered Kite
Blouvalk

39 ☐ Yellow-billed Kite
Geelbekwou

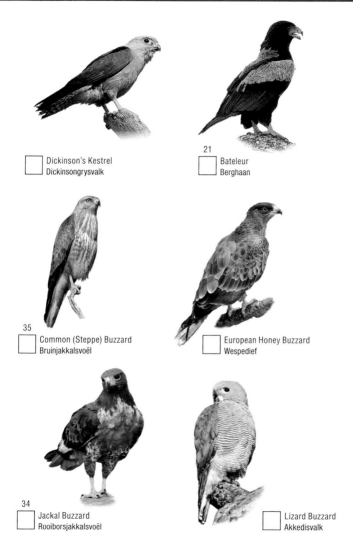

Dickinson's Kestrel
Dickinsongrysvalk

21
Bateleur
Berghaan

35
Common (Steppe) Buzzard
Bruinjakkalsvoël

European Honey Buzzard
Wespedief

34
Jackal Buzzard
Rooiborsjakkalsvoël

Lizard Buzzard
Akkedisvalk

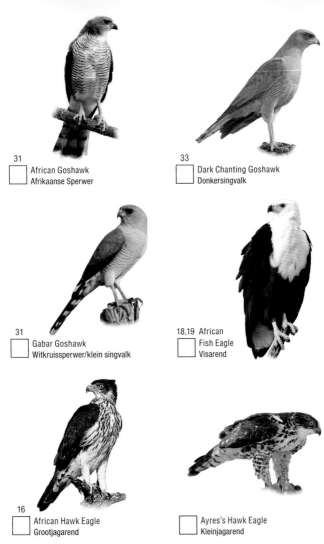

31
☐ African Goshawk
Afrikaanse Sperwer

33
☐ Dark Chanting Goshawk
Donkersingvalk

31
☐ Gabar Goshawk
Witkruissperwer/klein singvalk

18,19 African
☐ Fish Eagle
Visarend

16
☐ African Hawk Eagle
Grootjagarend

☐ Ayres's Hawk Eagle
Kleinjagarend

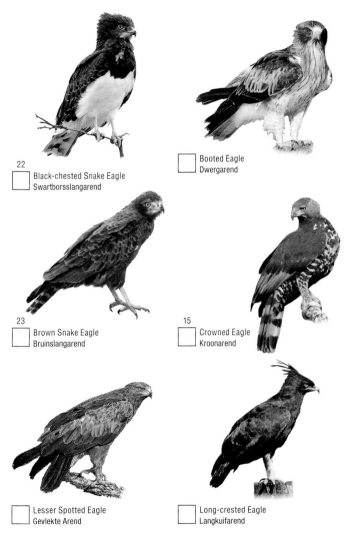

22
Black-chested Snake Eagle
Swartborsslangarend

Booted Eagle
Dwergarend

23
Brown Snake Eagle
Bruinslangarend

15
Crowned Eagle
Kroonarend

Lesser Spotted Eagle
Gevlekte Arend

Long-crested Eagle
Langkuifarend

247

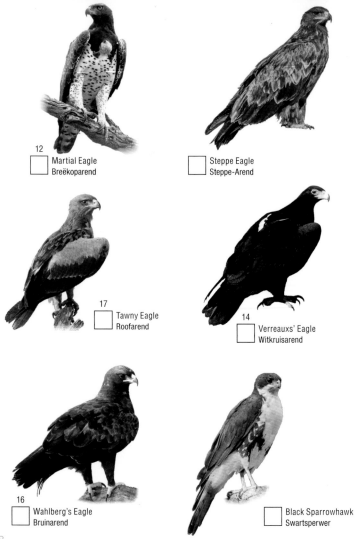

12 Martial Eagle
Breëkoparend

Steppe Eagle
Steppe-Arend

17 Tawny Eagle
Roofarend

14 Verreauxs' Eagle
Witkruisarend

16 Wahlberg's Eagle
Bruinarend

Black Sparrowhawk
Swartsperwer

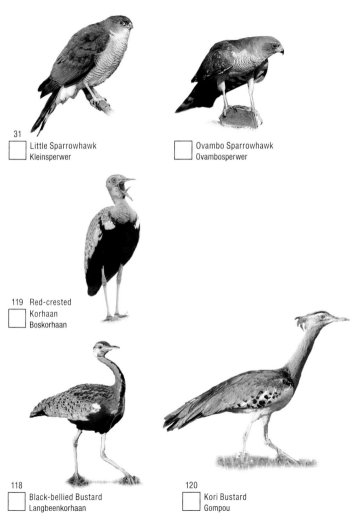

31
- [ ] Little Sparrowhawk
  Kleinsperwer

- [ ] Ovambo Sparrowhawk
  Ovambosperwer

119
- [ ] Red-crested
  Korhaan
  Boskorhaan

118
- [ ] Black-bellied Bustard
  Langbeenkorhaan

120
- [ ] Kori Bustard
  Gompou

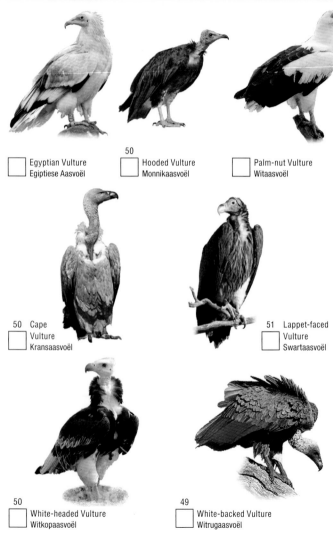

☐ Egyptian Vulture
    Egiptiese Aasvoël

50
☐ Hooded Vulture
    Monnikaasvoël

☐ Palm-nut Vulture
    Witaasvoël

50  Cape
☐ Vulture
    Kransaasvoël

51  Lappet-faced
☐ Vulture
    Swartaasvoël

50
☐ White-headed Vulture
    Witkopaasvoël

49
☐ White-backed Vulture
    Witrugaasvoël

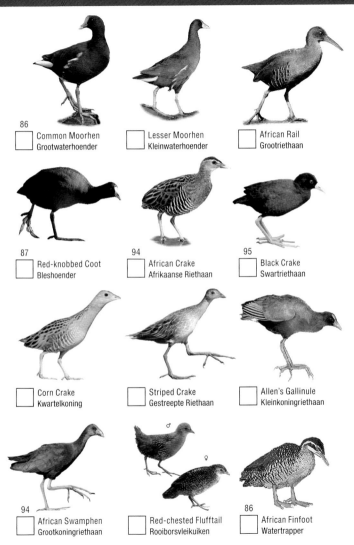

86
☐ Common Moorhen
Grootwaterhoender

☐ Lesser Moorhen
Kleinwaterhoender

☐ African Rail
Grootriethaan

87
☐ Red-knobbed Coot
Bleshoender

94
☐ African Crake
Afrikaanse Riethaan

95
☐ Black Crake
Swartriethaan

☐ Corn Crake
Kwartelkoning

☐ Striped Crake
Gestreepte Riethaan

☐ Allen's Gallinule
Kleinkoningriethaan

94
☐ African Swamphen
Grootkoningriethaan

☐ Red-chested Flufftail
Rooiborsvleikuiken

86
☐ African Finfoot
Watertrapper

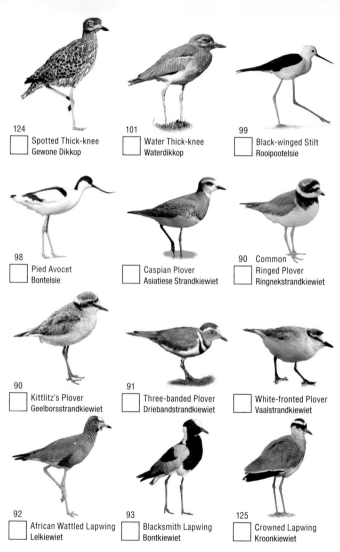

124 Spotted Thick-knee
Gewone Dikkop

101 Water Thick-knee
Waterdikkop

99 Black-winged Stilt
Rooipootelsie

98 Pied Avocet
Bontelsie

Caspian Plover
Asiatiese Strandkiewiet

90 Common Ringed Plover
Ringnekstrandkiewiet

90 Kittlitz's Plover
Geelborsstrandkiewiet

91 Three-banded Plover
Driebandstrandkiewiet

White-fronted Plover
Vaalstrandkiewiet

92 African Wattled Lapwing
Lelkiewiet

93 Blacksmith Lapwing
Bontkiewiet

125 Crowned Lapwing
Kroonkiewiet

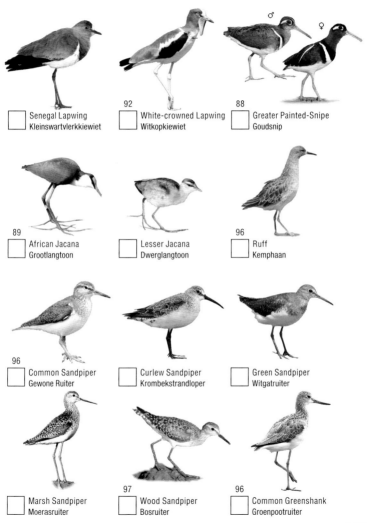

Senegal Lapwing
Kleinswartvlerkkiewiet

92 White-crowned Lapwing
Witkopkiewiet

88 Greater Painted-Snipe
Goudsnip

89 African Jacana
Grootlangtoon

Lesser Jacana
Dwerglangtoon

96 Ruff
Kemphaan

96 Common Sandpiper
Gewone Ruiter

Curlew Sandpiper
Krombekstrandloper

Green Sandpiper
Witgatruiter

Marsh Sandpiper
Moerasruiter

97 Wood Sandpiper
Bosruiter

96 Common Greenshank
Groenpootruiter

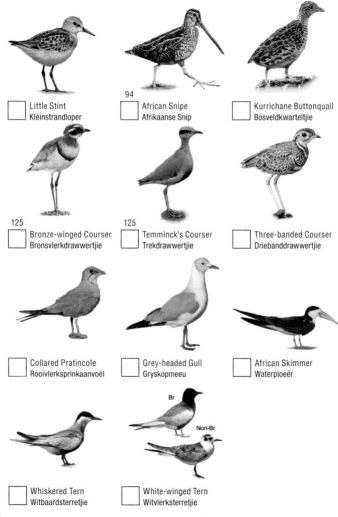

Little Stint
Kleinstrandloper

94
African Snipe
Afrikaanse Snip

Kurrichane Buttonquail
Bosveldkwarteltjie

125
Bronze-winged Courser
Bronsvlerkdrawwertjie

125
Temminck's Courser
Trekdrawwertjie

Three-banded Courser
Driebanddrawwertjie

Collared Pratincole
Rooivlerksprinkaanvoël

Grey-headed Gull
Gryskopmeeu

African Skimmer
Waterploeër

Whiskered Tern
Witbaardsterretjie

Br
Non-Br
White-winged Tern
Witvlerksterretjie

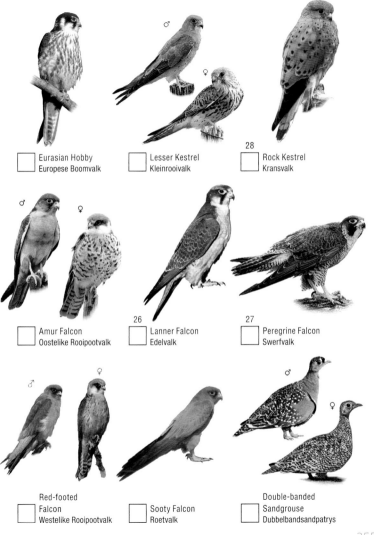

Eurasian Hobby
Europese Boomvalk

Lesser Kestrel
Kleinrooivalk

28 Rock Kestrel
Kransvalk

Amur Falcon
Oostelike Rooipootvalk

26 Lanner Falcon
Edelvalk

27 Peregrine Falcon
Swerfvalk

Red-footed
Falcon
Westelike Rooipootvalk

Sooty Falcon
Roetvalk

Double-banded
Sandgrouse
Dubbelbandsandpatrys

255

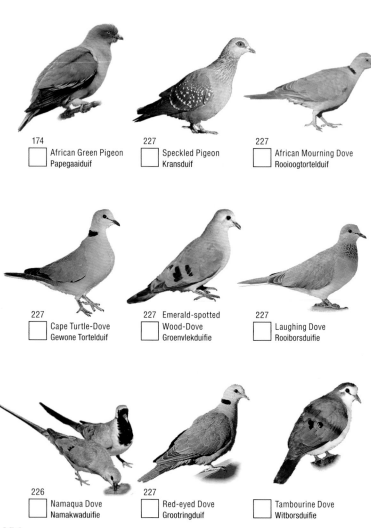

174
☐ African Green Pigeon
Papegaaiduif

227
☐ Speckled Pigeon
Kransduif

227
☐ African Mourning Dove
Rooioogtortelduif

227
☐ Cape Turtle-Dove
Gewone Tortelduif

227 Emerald-spotted
☐ Wood-Dove
Groenvlekduifie

227
☐ Laughing Dove
Rooiborsduifie

226
☐ Namaqua Dove
Namakwaduifie

227
☐ Red-eyed Dove
Grootringduif

☐ Tambourine Dove
Witborsduifie

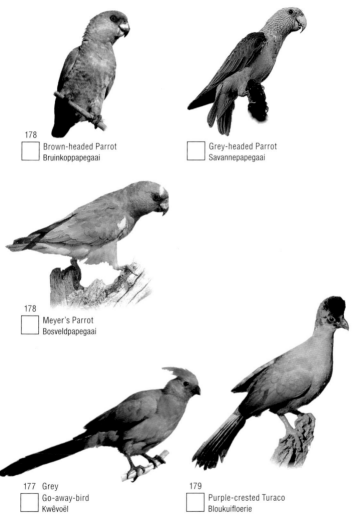

178
Brown-headed Parrot
Bruinkoppapegaai

Grey-headed Parrot
Savannepapegaai

178
Meyer's Parrot
Bosveldpapegaai

177 Grey
Go-away-bird
Kwêvoël

179
Purple-crested Turaco
Bloukuifloerie

257

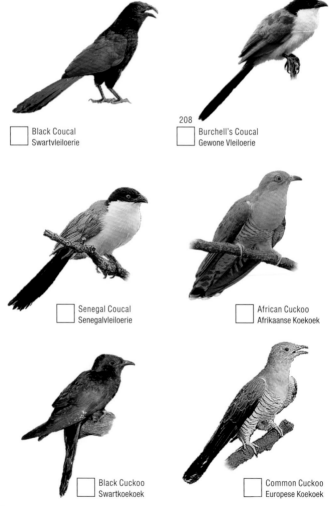

Black Coucal
Swartvleiloerie

208
Burchell's Coucal
Gewone Vleiloerie

Senegal Coucal
Senegalvleiloerie

African Cuckoo
Afrikaanse Koekoek

Black Cuckoo
Swartkoekoek

Common Cuckoo
Europese Koekoek

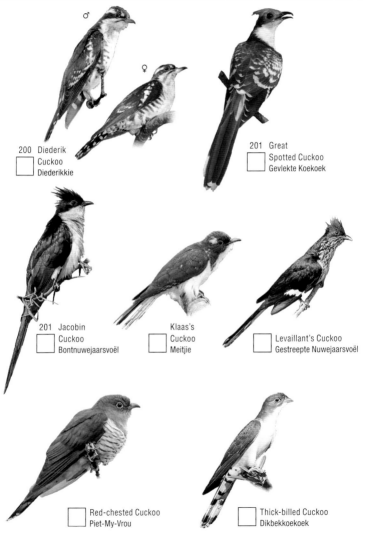

♂

♀

200 Diederik
Cuckoo
Diederikkie

201 Great
Spotted Cuckoo
Gevlekte Koekoek

201 Jacobin
Cuckoo
Bontnuwejaarsvoël

Klaas's
Cuckoo
Meitjie

Levaillant's Cuckoo
Gestreepte Nuwejaarsvoël

Red-chested Cuckoo
Piet-My-Vrou

Thick-billed Cuckoo
Dikbekkoekoek

259

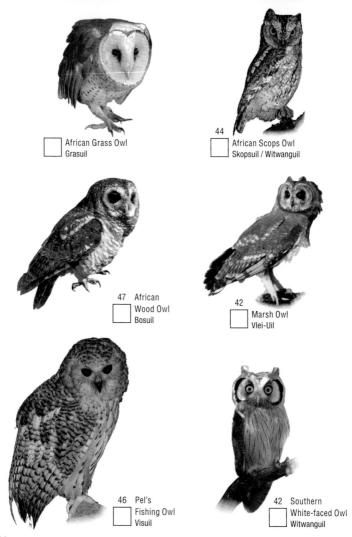

African Grass Owl
Grasuil

44 African Scops Owl
Skopsuil / Witwanguil

47 African
Wood Owl
Bosuil

42 Marsh Owl
Vlei-Uil

46 Pel's
Fishing Owl
Visuil

42 Southern
White-faced Owl
Witwanguil

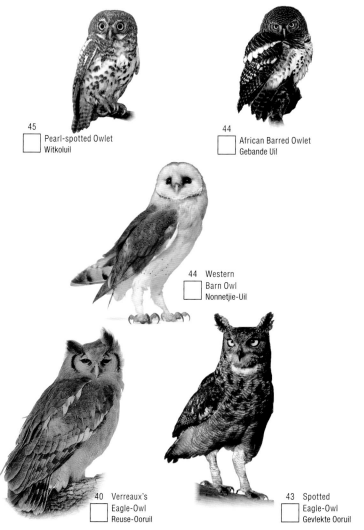

45
Pearl-spotted Owlet
Witkoluil

44
African Barred Owlet
Gebande Uil

44 Western
Barn Owl
Nonnetjie-Uil

40 Verreaux's
Eagle-Owl
Reuse-Ooruil

43 Spotted
Eagle-Owl
Gevlekte Ooruil

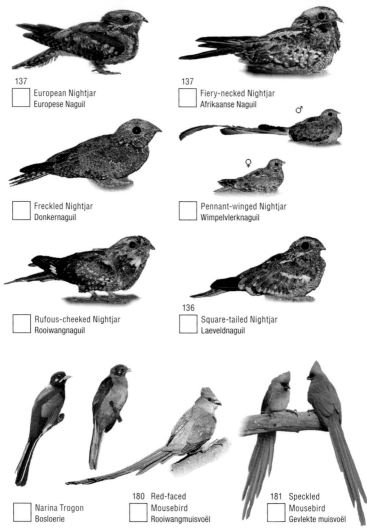

137
☐ European Nightjar
Europese Naguil

137
☐ Fiery-necked Nightjar
Afrikaanse Naguil

☐ Freckled Nightjar
Donkernaguil

♂
♀
☐ Pennant-winged Nightjar
Wimpelvlerknaguil

☐ Rufous-cheeked Nightjar
Rooiwangnaguil

136
☐ Square-tailed Nightjar
Laeveldnaguil

☐ Narina Trogon
Bosloerie

180 Red-faced
☐ Mousebird
Rooiwangmuisvoël

181 Speckled
☐ Mousebird
Gevlekte muisvoël

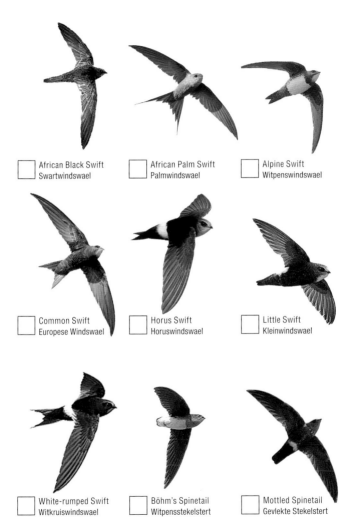

☐ African Black Swift
Swartwindswael

☐ African Palm Swift
Palmwindswael

☐ Alpine Swift
Witpenswindswael

☐ Common Swift
Europese Windswael

☐ Horus Swift
Horuswindswael

☐ Little Swift
Kleinwindswael

☐ White-rumped Swift
Witkruiswindswael

☐ Böhm's Spinetail
Witpensstekelstert

☐ Mottled Spinetail
Gevlekte Stekelstert

164 African Pygmy Kingfisher
Dwergvisvanger

107 Malachite Kingfisher
Kuifkopvisvanger

Half-collared Kingfisher
Blouvisvanger

167 Brown-hooded Kingfisher
Bruinkopvisvanger

Grey-headed Kingfisher
Gryskopvisvanger

109 Giant Kingfisher
Reusevisvanger

108 Pied Kingfisher
Bontvisvanger

166 Striped Kingfisher
Gestreepte visvanger

165 Woodland Kingfisher
Bosveldvisvanger

264

Blue-cheeked Bee-eater
Blouwangbyvreter

158 European Bee-eater
Europese Byvreter

160 Little Bee-eater
Kleinbyvreter

159 Southern
Carmine Bee-eater
Rooiborsbyvreter

Swallow-tailed
Bee-eater
Swaelstertbyvreter

161 White-fronted
Bee-eater
Rooikeelbyvreter

265

Broad-billed Roller
Geelbektroupant

157 European Roller
Europese Troupant

154 Lilac-breasted Roller
Gewone Troupant

156 Purple Roller
Groottroupant

Racket-tailed
Roller
Knopsterttroupant

152 Green
Wood-Hoopoe
Rooibekkakelaar

152 African Hoopoe
Hoephoep

153 Common
Scimitarbill
Swartbekkakelaar

151 African Grey Hornbill
Grysneushoringvoël

150 Crowned Hornbill
Gekroonde Neushoringvoël

149 Southern
Yellow-billed Hornbill
Geelbekneushoringvoël

148 Southern
Red-billed Hornbill
Rooibekneushoringvoël

150 Trumpeter Hornbill
Gewone Boskraai

114 Southern
Ground-Hornbill
Bromvoël

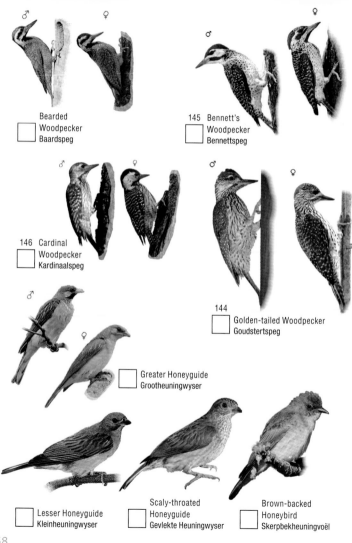

Bearded
Woodpecker
Baardspeg

145 Bennett's
Woodpecker
Bennettspeg

146 Cardinal
Woodpecker
Kardinaalspeg

144
Golden-tailed Woodpecker
Goudstertspeg

Greater Honeyguide
Grootheuningwyser

Lesser Honeyguide
Kleinheuningwyser

Scaly-throated
Honeyguide
Gevlekte Heuningwyser

Brown-backed
Honeybird
Skerpbekheuningvoël

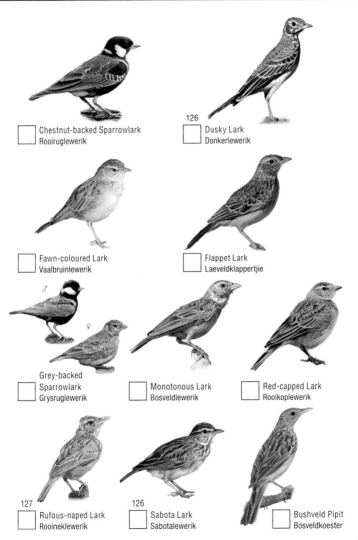

Chestnut-backed Sparrowlark
Rooiruglewerik

126
Dusky Lark
Donkerlewerik

Fawn-coloured Lark
Vaalbruinlewerik

Flappet Lark
Laeveldklappertjie

♂
♀
Grey-backed
Sparrowlark
Grysruglewerik

Monotonous Lark
Bosveldlewerik

Red-capped Lark
Rooikoplewerik

127
Rufous-naped Lark
Rooineklewerik

126
Sabota Lark
Sabotalewerik

Bushveld Pipit
Bosveldkoester

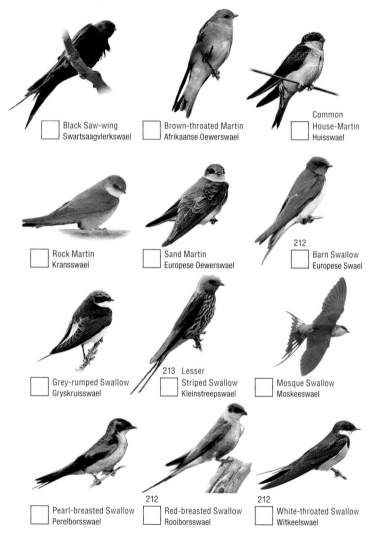

Black Saw-wing
Swartsaagvlerkswael

Brown-throated Martin
Afrikaanse Oewerswael

Common
House-Martin
Huisswael

Rock Martin
Kransswael

Sand Martin
Europese Oewerswael

212
Barn Swallow
Europese Swael

Grey-rumped Swallow
Gryskruisswael

213 Lesser
Striped Swallow
Kleinstreepswael

Mosque Swallow
Moskeeswael

Pearl-breasted Swallow
Perelborsswael

212
Red-breasted Swallow
Rooiborsswael

212
White-throated Swallow
Witkeelswael

270

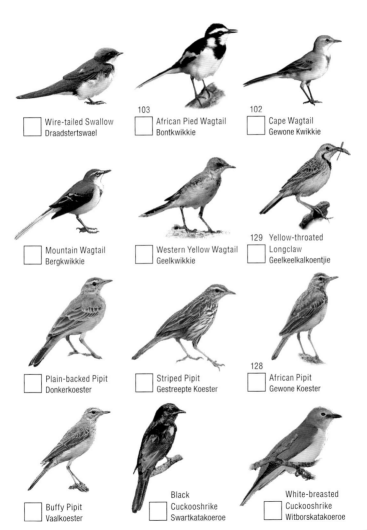

Wire-tailed Swallow
Draadstertswael

103 African Pied Wagtail
Bontkwikkie

102 Cape Wagtail
Gewone Kwikkie

Mountain Wagtail
Bergkwikkie

Western Yellow Wagtail
Geelkwikkie

129 Yellow-throated Longclaw
Geelkeelkalkoentjie

Plain-backed Pipit
Donkerkoester

Striped Pipit
Gestreepte Koester

128 African Pipit
Gewone Koester

Buffy Pipit
Vaalkoester

Black Cuckooshrike
Swartkatakoeroe

White-breasted Cuckooshrike
Witborskatakoeroe

271

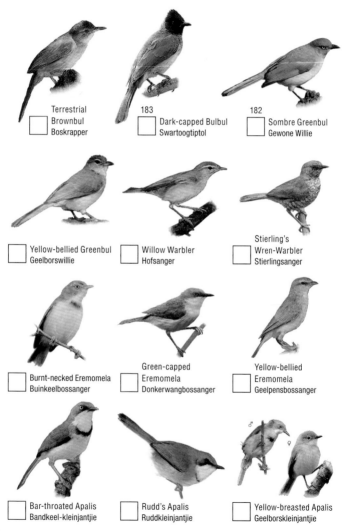

Terrestrial Brownbul
Boskrapper

183 Dark-capped Bulbul
Swartoogtiptol

182 Sombre Greenbul
Gewone Willie

Yellow-bellied Greenbul
Geelborswillie

Willow Warbler
Hofsanger

Stierling's Wren-Warbler
Stierlingsanger

Burnt-necked Eremomela
Buinkeelbossanger

Green-capped Eremomela
Donkerwangbossanger

Yellow-bellied Eremomela
Geelpensbossanger

Bar-throated Apalis
Bandkeel-kleinjantjie

Rudd's Apalis
Ruddkleinjantjie

Yellow-breasted Apalis
Geelborskleinjantjie

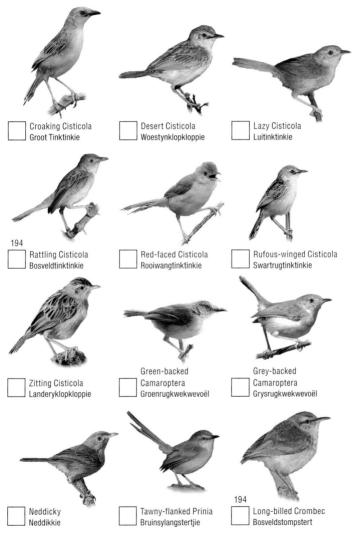

Croaking Cisticola
Groot Tinktinkie

Desert Cisticola
Woestynklopkloppie

Lazy Cisticola
Luitinktinkie

194

Rattling Cisticola
Bosveldtinktinkie

Red-faced Cisticola
Rooiwangtinktinkie

Rufous-winged Cisticola
Swartrugtinktinkie

Zitting Cisticola
Landeryklopkloppie

Green-backed
Camaroptera
Groenrugkwekwevoël

Grey-backed
Camaroptera
Grysrugkwekwevoël

Neddicky
Neddikkie

Tawny-flanked Prinia
Bruinsylangstertjie

194

Long-billed Crombec
Bosveldstompstert

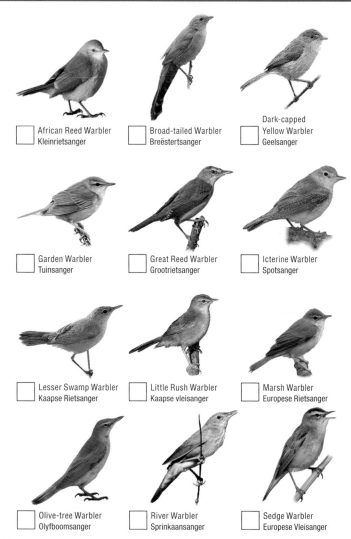

- [ ] African Reed Warbler
  Kleinrietsanger

- [ ] Broad-tailed Warbler
  Breëstertsanger

- [ ] Dark-capped
  Yellow Warbler
  Geelsanger

- [ ] Garden Warbler
  Tuinsanger

- [ ] Great Reed Warbler
  Grootrietsanger

- [ ] Icterine Warbler
  Spotsanger

- [ ] Lesser Swamp Warbler
  Kaapse Rietsanger

- [ ] Little Rush Warbler
  Kaapse vleisanger

- [ ] Marsh Warbler
  Europese Rietsanger

- [ ] Olive-tree Warbler
  Olyfboomsanger

- [ ] River Warbler
  Sprinkaansanger

- [ ] Sedge Warbler
  Europese Vleisanger

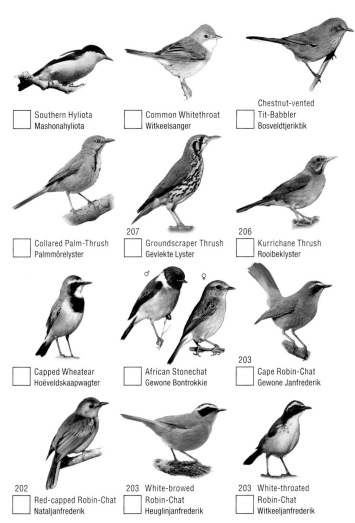

☐ Southern Hyliota
Mashonahyliota

☐ Common Whitethroat
Witkeelsanger

☐ Chestnut-vented
Tit-Babbler
Bosveldtjeriktik

☐ Collared Palm-Thrush
Palmmôrelyster

207 ☐ Groundscraper Thrush
Gevlekte Lyster

206 ☐ Kurrichane Thrush
Rooibeklyster

☐ Capped Wheatear
Hoëveldskaapwagter

☐ African Stonechat
Gewone Bontrokkie

203 ☐ Cape Robin-Chat
Gewone Janfrederik

202 ☐ Red-capped Robin-Chat
Nataljanfrederik

203 ☐ White-browed
Robin-Chat
Heuglinjanfrederik

203 ☐ White-throated
Robin-Chat
Witkeeljanfrederik

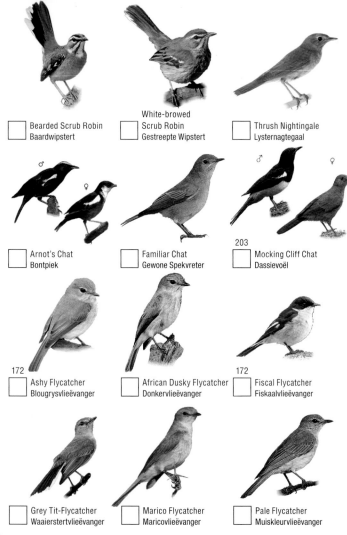

- [ ] Bearded Scrub Robin
  Baardwipstert

- [ ] White-browed Scrub Robin
  Gestreepte Wipstert

- [ ] Thrush Nightingale
  Lysternagtegaal

- [ ] Arnot's Chat
  Bontpiek

- [ ] Familiar Chat
  Gewone Spekvreter

203
- [ ] Mocking Cliff Chat
  Dassievoël

172
- [ ] Ashy Flycatcher
  Blougrysvlieëvanger

- [ ] African Dusky Flycatcher
  Donkervlieëvanger

172
- [ ] Fiscal Flycatcher
  Fiskaalvlieëvanger

- [ ] Grey Tit-Flycatcher
  Waaierstertvlieëvanger

- [ ] Marico Flycatcher
  Maricovlieëvanger

- [ ] Pale Flycatcher
  Muiskleurvlieëvanger

276

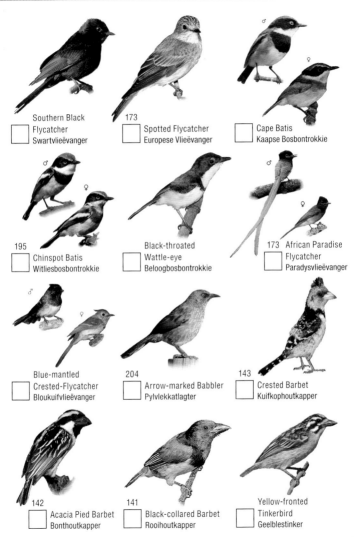

Southern Black
Flycatcher
Swartvlieëvanger

173 Spotted Flycatcher
Europese Vlieëvanger

Cape Batis
Kaapse Bosbontrokkie

195 Chinspot Batis
Witliesbosbontrokkie

Black-throated
Wattle-eye
Beloogbosbontrokkie

173 African Paradise
Flycatcher
Paradysvlieëvanger

Blue-mantled
Crested-Flycatcher
Bloukuifvlieëvanger

204 Arrow-marked Babbler
Pylvlekkatlagter

143 Crested Barbet
Kuifkophoutkapper

142 Acacia Pied Barbet
Bonthoutkapper

141 Black-collared Barbet
Rooihoutkapper

Yellow-fronted
Tinkerbird
Geelblestinker

277

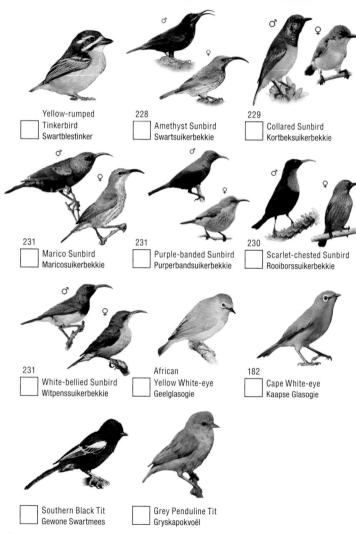

☐ Yellow-rumped Tinkerbird
Swartblestinker

228 ☐ Amethyst Sunbird
Swartsuikerbekkie

229 ☐ Collared Sunbird
Kortbeksuikerbekkie

231 ☐ Marico Sunbird
Maricosuikerbekkie

231 ☐ Purple-banded Sunbird
Purperbandsuikerbekkie

230 ☐ Scarlet-chested Sunbird
Rooiborssuikerbekkie

231 ☐ White-bellied Sunbird
Witpenssuikerbekkie

☐ African Yellow White-eye
Geelglasogie

182 ☐ Cape White-eye
Kaapse Glasogie

☐ Southern Black Tit
Gewone Swartmees

☐ Grey Penduline Tit
Gryskapokvoël

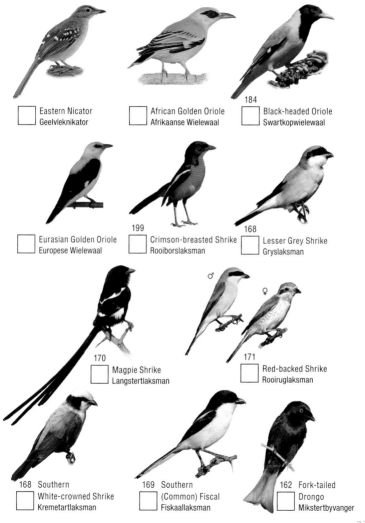

Eastern Nicator
Geelvleknikator

African Golden Oriole
Afrikaanse Wielewaal

184 Black-headed Oriole
Swartkopwielewaal

Eurasian Golden Oriole
Europese Wielewaal

199 Crimson-breasted Shrike
Rooiborslaksman

168 Lesser Grey Shrike
Gryslaksman

170 Magpie Shrike
Langstertlaksman

♂ ♀

171 Red-backed Shrike
Rooiruglaksman

168 Southern
White-crowned Shrike
Kremetartlaksman

169 Southern
(Common) Fiscal
Fiskaallaksman

162 Fork-tailed
Drongo
Mikstertbyvanger

279

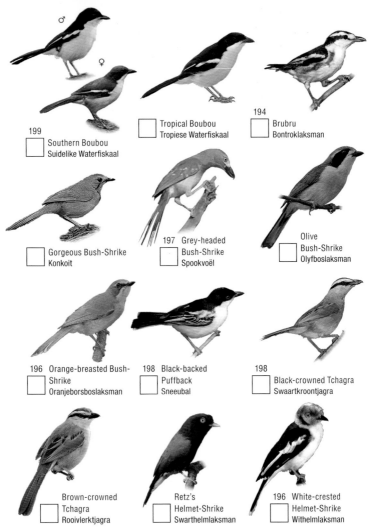

♂
♀

199
☐ Southern Boubou
Suidelike Waterfiskaal

☐ Tropical Boubou
Tropiese Waterfiskaal

194
☐ Brubru
Bontroklaksman

☐ Gorgeous Bush-Shrike
Konkoit

197 Grey-headed
☐ Bush-Shrike
Spookvoël

☐ Olive
Bush-Shrike
Olyfboslaksman

196 Orange-breasted Bush-
☐ Shrike
Oranjeborsboslaksman

198 Black-backed
☐ Puffback
Sneeubal

198
☐ Black-crowned Tchagra
Swaartkroontjagra

☐ Brown-crowned
Tchagra
Rooivlerktjagra

☐ Retz's
Helmet-Shrike
Swarthelmlaksman

196 White-crested
☐ Helmet-Shrike
Withelmlaksman

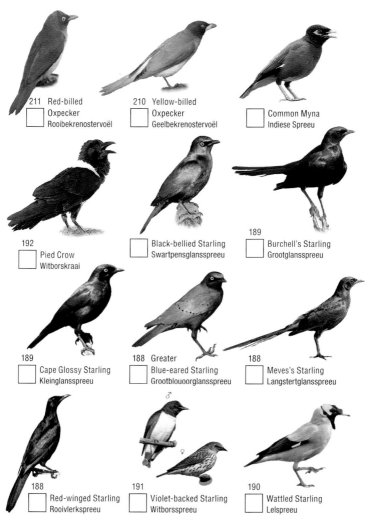

211 Red-billed Oxpecker
Rooibekrenostervoël

210 Yellow-billed Oxpecker
Geelbekrenostervoël

Common Myna
Indiese Spreeu

192 Pied Crow
Witborskraai

Black-bellied Starling
Swartpensglansspreeu

189 Burchell's Starling
Grootglansspreeu

189 Cape Glossy Starling
Kleinglansspreeu

188 Greater Blue-eared Starling
Grootblouoorglansspreeu

188 Meves's Starling
Langstertglansspreeu

188 Red-winged Starling
Rooivlerkspreeu

191 Violet-backed Starling
Witborsspreeu

190 Wattled Starling
Lelspreeu

281

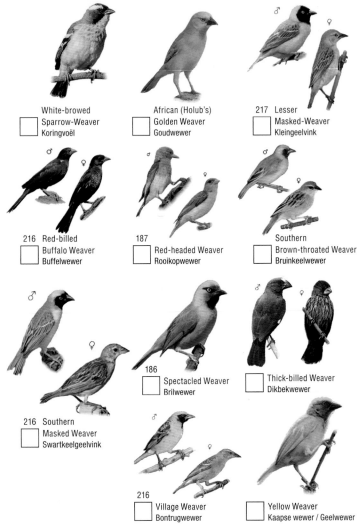

White-browed
Sparrow-Weaver
Koringvoël

African (Holub's)
Golden Weaver
Goudwewer

217 Lesser
Masked-Weaver
Kleingeelvink

216 Red-billed
Buffalo Weaver
Buffelwewer

187
Red-headed Weaver
Rooikopwewer

Southern
Brown-throated Weaver
Bruinkeelwewer

216 Southern
Masked Weaver
Swartkeelgeelvink

186
Spectacled Weaver
Brilwewer

Thick-billed Weaver
Dikbekwewer

216
Village Weaver
Bontrugwewer

Yellow Weaver
Kaapse wewer / Geelwewer

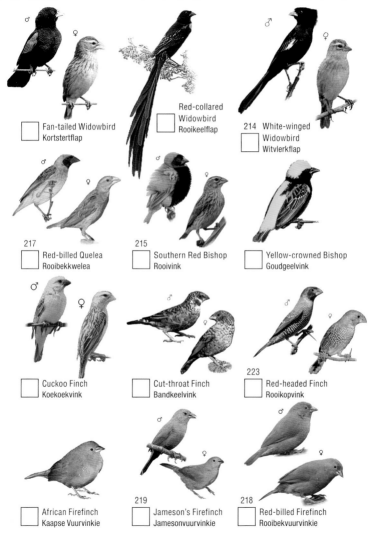

Fan-tailed Widowbird
Kortstertflap

Red-collared Widowbird
Rooikeelflap

214 White-winged Widowbird
Witvlerkflap

217 Red-billed Quelea
Rooibekkwelea

215 Southern Red Bishop
Rooivink

Yellow-crowned Bishop
Goudgeelvink

Cuckoo Finch
Koekoekvink

Cut-throat Finch
Bandkeelvink

223 Red-headed Finch
Rooikopvink

African Firefinch
Kaapse Vuurvinkie

219 Jameson's Firefinch
Jamesonvuurvinkie

218 Red-billed Firefinch
Rooibekvuurvinkie

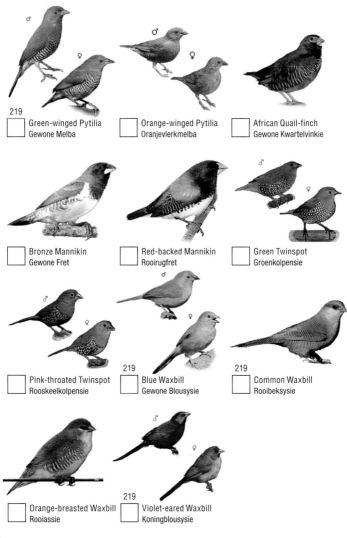

219

☐ Green-winged Pytilia
Gewone Melba

☐ Orange-winged Pytilia
Oranjevlerkmelba

☐ African Quail-finch
Gewone Kwartelvinkie

☐ Bronze Mannikin
Gewone Fret

☐ Red-backed Mannikin
Rooirugfret

☐ Green Twinspot
Groenkolpensie

☐ Pink-throated Twinspot
Rooskeelkolpensie

219
☐ Blue Waxbill
Gewone Blousysie

219
☐ Common Waxbill
Rooibeksysie

☐ Orange-breasted Waxbill
Rooiassie

219
☐ Violet-eared Waxbill
Koningblousysie

284

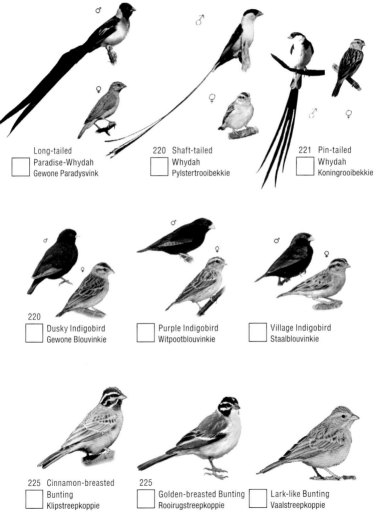

Long-tailed
Paradise-Whydah
Gewone Paradysvink

220  Shaft-tailed
Whydah
Pylstertrooibekkie

221  Pin-tailed
Whydah
Koningrooibekkie

220
Dusky Indigobird
Gewone Blouvinkie

Purple Indigobird
Witpootblouvinkie

Village Indigobird
Staalblouvinkie

225  Cinnamon-breasted
Bunting
Klipstreepkoppie

225
Golden-breasted Bunting
Rooirugstreepkoppie

Lark-like Bunting
Vaalstreepkoppie

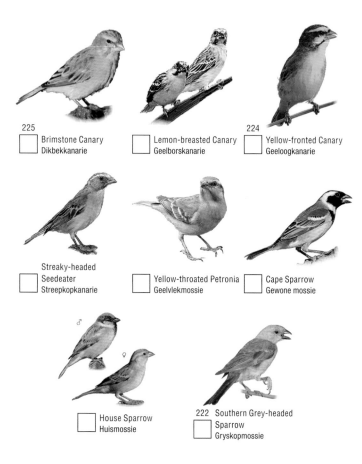

225
Brimstone Canary
Dikbekkanarie

Lemon-breasted Canary
Geelborskanarie

224
Yellow-fronted Canary
Geeloogkanarie

Streaky-headed
Seedeater
Streepkopkanarie

Yellow-throated Petronia
Geelvlekmossie

Cape Sparrow
Gewone mossie

House Sparrow
Huismossie

222 Southern Grey-headed
Sparrow
Gryskopmossie

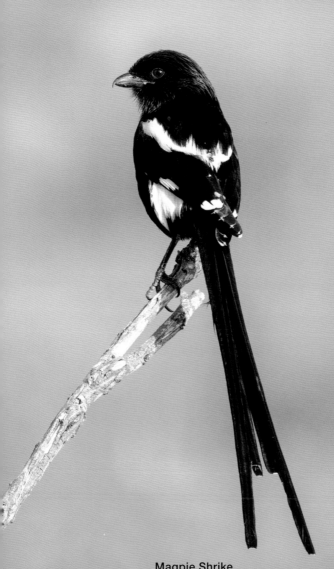

Magpie Shrike

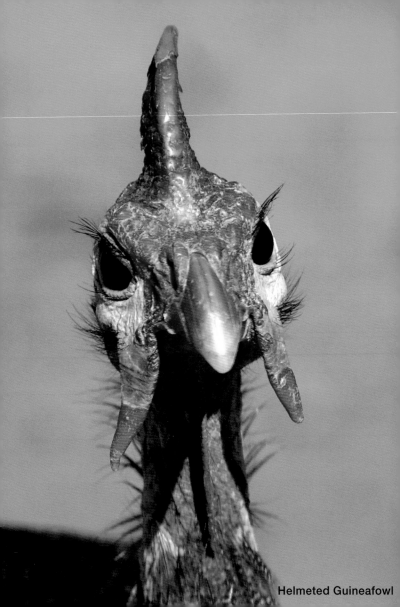

Helmeted Guineafowl

# INDEX

# A

Apalis, Bar-throated 272

Apalis, Rudd's 272

Apalis, Yellow-breasted 272

Arend, Bruin- 248

Arend, Grootjag- 246

Arend, Roof- 248

Arend, Vis- 246

Arend, Witkruis- 248

Avocet, Pied 98, 252

# B

Babbler, Arrow-marked 204, 277

Barbet, Acacia Pied 142, 277

Barbet, Black-collared 140, 277

Barbet, Crested 3, 142, 277

Bateleur 11, 20, 245

Batis, Cape 277

Batis, Chinspot 194, 277

Bee-eater, Blue-cheeked 265

Bee-eater, European 158, 265

Bee-eater, Little 160, 265

Bee-eater, Southern Carmine 158, 265

Bee-eater, Swallow-tailed 265

Bee-eater, White-fronted 160, 265

Bishop, Southern Red 214, 283

Bishop, Yellow-crowned 283

Bittern, Dwarf 242

Bittern, Little 242

Black-crowned Tchagras 198

Boubou, Southern 198, 280

Boubou, Tropical 280

Brownbul, Terrestrial 272

Brubru 194, 280

Bulbul, Dark-capped 182, 272

Bunting, Cinnamon-breasted 224, 285

Bunting, Golden-breasted 224, 285

Bunting, Lark-like 285

Bush-shrike, Grey-headed 196

Bush-shrike, Orange-breasted 196

Bustard, Black-bellied 118, 249

Bustard, Kori 8, 120, 249

Buttonquail, Kurrichane 254

Buzzard, Common (Steppe) 34, 245

Buzzard, European Honey 245

Buzzard, Jackal 245

Buzzard, Lizard 245

# C

Camaroptera, Green-backed 273

Camaroptera, Grey-backed 273

Canary, Brimstone 224, 286

Canary, Lemon-breasted 286

Canary, Yellow-fronted  224, 286

Chat, Arnot's  276

Chat, Familiar  276

Chat, Mocking Cliff  202, 276

Cisticola, Croaking  273

Cisticola, Desert  273

Cisticola, Lazy  273

Cisticola, Rattling  194, 273

Cisticola, Red-faced  273

Cisticola, Rufous-winged  273

Cisticola, Zitting  273

Coot, Red-knobbed  86, 251

Cormorant, Reed  82, 238

Cormorant, White-breasted  82, 238

Coucal, Black  258

Coucal, Burchell's  208, 258

Coucal, Senegal  258

Courser, Bronze-winged  124, 254

Courser, Temminck's  124, 254

Courser, Three-banded  254

Crake, African  94, 251

Crake, Black  94, 251

Crake, Corn  251

Crake, Striped  251

Crombec, Long-billed  194, 273

Crow, Pied  192, 281

Cuckoo, African  258

Cuckoo, Black  258

Cuckoo, Common  258

Cuckoo, Diederik  200, 259

Cuckoo, Great Spotted  200, 259

Cuckoo, Jacobin  200, 259

Cuckoo, Klaas's  259

Cuckoo, Levaillant's  259

Cuckoo, Red-chested  259

Cuckooshrike, Black  271

Cuckooshrike, White-breasted  271

Cuckoo, Thick-billed  259

## D

Darter, African  84, 238

Dove, African Mourning  226, 256

Dove, Cape Turtle-  226, 256

Dove, Emerald-spotted Wood-  256

Dove, Laughing  226, 256

Dove, Namaqua  226, 256

Dove, Red-eyed  226, 256

Dove, Tambourine  256

Drongo, Fork-tailed  162, 279

Duck, African Black  236

Duck, Fulvous Whistling  58, 236

Duck, Knob-billed  56, 236

Duck, White-backed  236

Duck, White-faced Whistling  58, 236

Duck, Yellow-billed  60, 237

# E

Eagle, African Fish  18, 246

Eagle, African Hawk  16, 246

Eagle, Ayres's Hawk  246

Eagle, Black-chested Snake  22, 247

Eagle, Booted  247

Eagle, Brown Snake  22, 247

Eagle, Crowned  14, 247

Eagle, Lesser Spotted  247

Eagle, Long-crested  247

Eagle, Martial  8, 12, 248

Eagle, Steppe  248

Eagle, Tawny  248

Eagle, Verreauxs'  14, 248

Eagle, Wahlberg's  16, 248

Egret, Great  66, 241

Egret, Little  66, 241

Egret, Western Cattle  7, 110, 122, 241

Egret, Yellow-billed (Intermediate)  241

Eremomela, Burnt-necked  272

Eremomela, Green-capped  272

Eremomela, Yellow-bellied  272

# F

Falcon, Amur  255

Falcon, Lanner  26, 255

Falcon, Peregrine  26, 255

Falcon, Red-footed  255

Falcon, Sooty  255

Finch, Cuckoo  283

Finch, Cut-throat  283

Finch, Red-headed  222, 283

Finfoot, African  86, 251

Firefinch, African  283

Firefinch, Jameson's  218, 283

Firefinch, Red-billed  218, 283

Fiscal, Southern (Common)  168, 279

Flamingo, Greater  234

Flamingo, Lesser  234

Flufftail, Red-chested  251

Flycatcher, African Dusky  276

Flycatcher, African Paradise  172, 277

Flycatcher, Ashy  172, 276

Flycatcher, Blue-mantled Crested-  277

Flycatcher, Fiscal  172, 276

Flycatcher, Grey Tit-  276

Flycatcher, Marico  276

Flycatcher, Pale  276

Flycatcher, Southern Black  277

Flycatcher, Spotted  172, 277

Francolin, Coqui  132, 235

Francolin, Crested  132, 235

Francolin, Shelley's  132, 235

# G

Gallinule, Allen's  251

Go-away-bird, Grey  174, 257

Goose, African Pygmy  60, 237

Goose, Egyptian  54, 237

Goose, Spur-winged  56, 237

Goshawk, African  30, 246

Goshawk, Dark Chanting  32, 246

Goshawk, Gabar  30, 246

Grebe, Little  82, 238

Greenbul, Sombre  182, 272

Greenbul, Yellow-bellied  272

Greenshank, Common  96, 253

Ground-Hornbill, Southern  9, 114, 267

Guineafowl, Crested  134, 234

Guineafowl, Helmeted  134, 234

Gull, Grey-headed  254

# H

Hamerkop  70, 238

Harrier, African Marsh  243

Harrier, Montagu's  243

Harrier, Pallid  243

Hawk, African Cuckoo  244

Hawk, African Harrier-  24, 244

Hawk, Bat  244

Heron, Black  68, 240

Heron, Black-crowned Night-  68, 240

Heron, Black-headed  122, 240

Heron, Goliath  62, 240

Heron, Green-backed  68, 240

Heron, Grey  64, 241

Heron, Purple  64, 241

Heron, Squacco  68, 240

Heron, White-backed Night-  241

Hobby, Eurasian  255

Honeybird, Brown-backed  268

Honeyguide, Greater  268

Honeyguide, Lesser  268

Honeyguide, Scaly-throated  268

Hoopoe, African  152, 266

Hornbill, African Grey  150, 267

Hornbill, Crowned  150, 267

Hornbill, Southern Ground-  114

Hornbill, Southern Red-billed  148, 267

Hornbill, Southern Yellow-billed  148, 267

Hornbill, Trumpeter  150, 267

Hyliota, Southern  275

# I

Ibis, African Sacred  78, 242

Ibis, Glossy  78, 242

Ibis, Hadeda  78, 242

Indigobird, Dusky  285

Indigobird, Purple  285

Indigobird, Village  285

# J

Jacana, African  88, 253

Jacana, Lesser  253

# K

Kestrel, Dickinson's  245

Kestrel, Lesser  255

Kestrel, Rock  28, 255

Kingfisher, African Pygmy  164, 264

Kingfisher, Brown-hooded  166, 264

Kingfisher, Giant  108, 264

Kingfisher, Grey-headed  264

Kingfisher, Half-collared  264

Kingfisher, Malachite  4, 264

Kingfisher, Pied  108, 264

Kingfisher, Striped  166, 264

Kingfisher, Woodland  164, 264

Kite, Black  244

Kite, Black-shouldered  36, 244

Kite, Yellow-billed  38, 244

Korhaan, Red-crested  118, 249

# L

Lapwing, African Wattled  92, 252

Lapwing, Blacksmith  92, 232, 252

Lapwing, Crowned  124, 252

Lapwing, Senegal  253

Lapwing, White-crowned  92, 253

Lark, Dusky  126, 269

Lark, Fawn-coloured  269

Lark, Flappet  269

Lark, Monotonous  269

Lark, Red-capped  269

Lark, Rufous-naped  126, 269

Lark, Sabota  126, 269

Longclaw, Yellow-throated  128, 271

# M

Mannikin, Bronze  284

Mannikin, Red-backed  284

Martin, Brown-throated  270

Martin, Common House-  270

Martin, Rock  270

Martin, Sand  270

Masked Weaver, Southern  282

Moorhen, Common  86, 251

Moorhen, Lesser  251

Mousebird, Red-faced  180, 262

Mousebird, Speckled  180, 262

Myna, Common  281

# N

Neddicky  273

Nicator, Eastern  279

Nightingale, Thrush  276

Nightjar, European  136, 262

Nightjar, Fiery-necked  136, 262

Nightjar, Freckled  262

Nightjar, Pennant-winged  262

Nightjar, Rufous-cheeked  262

Nightjar, Square-tailed  136, 262

# O

Openbill, African  74, 239

Oriole, African Golden  279

Oriole, Black-headed  182, 279

Oriole, Eurasian Golden  279

Osprey, Western  36, 243

Ostrich, Common  112, 234

Owl, African Grass  260

Owl, African Scops  44, 260

Owl, African Wood  46, 260

Owlet, African Barred  44, 261

Owlet, Pearl-spotted  261

Owl, Marsh  260

Owl, Pel's Fishing  8, 46, 260

Owl, Southern White-faced  260

Owl, Spotted Eagle-  261

Owl, Verreaux's Eagle-  40, 261

Owl, Western Barn  44, 261

Oxpecker, Red-billed  210, 281

Oxpecker, Yellow-billed  210, 281

# P

Painted-snipe, Greater  88

Palm-Thrush, Collared  275

Parrot, Brown-headed  178, 257

Parrot, Grey-headed  257

Parrot, Meyer's  178, 257

Pelican, Great White  238

Petronia, Yellow-throated  286

Pigeon, African Green  174, 256

Pigeon, Speckled  226, 256

Pipit, African  128, 271

Pipit, Buffy  271

Pipit, Bushveld  269

Pipit, Plain-backed  271

Pipit, Striped  271

Plover, Caspian  252

Plover, Common Ringed  252

Plover, Kittlitz's  90, 252

Plover, Three-banded  90, 252

Plover, White-fronted  252

Pochard, Southern  60, 236

Pratincole, Collared  254

Prinia, Tawny-flanked  273

Puffback, Black-backed  198, 280

Pytilia, Green-winged  284

Pytilia, Orange-winged  284

Pytillia, Green-winged  218

# Q

Quail-finch, African  284

Quail, Harlequin  235

Quelea, Red-billed  216, 283

# R

Rail, African  251

Robin, Bearded Scrub  276

Robin-Chat, Cape  275

Robin-Chat, Red-capped  202, 275

Robin-Chat, White-browed  202, 275

Robin-Chat, White-throated  202, 275

Robin, White-browed Scrub  276

Roller, Broad-billed  266

Roller, European  156, 266

Roller, Lilac-breasted  1, 154, 266

Roller, Purple  156, 266

Roller, Racket-tailed  266

Ruff  96, 253

# S

Sandgrouse, Double-banded  255

Sandpiper, Common  96, 253

Sandpiper, Curlew  253

Sandpiper, Green  253

Sandpiper, Marsh  253

Sandpiper, Wood  96, 253

Saw-wing, Black  270

Scimitarbill, Common  152, 266

Secretarybird  116, 243

Seedeater, Streaky-headed  286

Shikra  30, 243

Shoveller, Cape  60

Shrike, Crimson-breasted  279

Shrike, Gorgeous Bush-  280

Shrike, Grey-headed Bush-  280

Shrike, Lesser Grey  168, 279

Shrike, Magpie  170, 279

Shrike, Olive Bush-  280

Shrike, Orange-breasted Bush-  280

Shrike, Red-backed  170, 279

Shrike, Retz's Helmet-  280

Shrike, Southern White-crowned  168, 279

Shrike, White-crested Helmet-  196, 280

Skimmer, African  254

Snipe, African  94, 254

Snipe, Greater Painted-  253

Southern Grey-headed Sparrow  286

Sparrow, Cape  286

Sparrowhawk, Black  248

Sparrowhawk, Little  30, 249

Sparrowhawk, Ovambo  249

Sparrow, House  286

Sparrowlark, Chestnut-backed  269

Sparrowlark, Grey-backed  269

Sparrow, Southern Grey-headed  222, 286

Spinetail, Böhm's  263

Spinetail, Mottled  263

Spoonbill, African  78, 242

Spurfowl, Natal  130, 235

Spurfowl, Swainson's  130, 235

Starling, Black-bellied  281

Starling, Burchell's  188, 281

Starling, Cape Glossy  188, 281

Starling, Greater Blue-eared  188, 281

Starling, Meves's  188, 281

Starling, Red-winged  188, 281

Starling, Violet-backed  190, 281

Starling, Wattled  190

Starling, White-browed Sparrow-  281

Stilt, Black-winged  98, 252

Stint, Little  254

Stonechat, African  275

Stork, Abdim's  122, 239

Stork, Black  72, 238

Stork, Marabou  76, 239

Stork, Saddle-billed  9, 72, 239

Stork, White  122, 239

Stork, Woolly-necked  76, 239

Stork, Yellow-billed  74, 238

Sunbird, Amethyst  278

Sunbird, Collared  278

Sunbird, Marico  230, 278

Sunbird, Purple-banded  278

Sunbird, Scarlet-chested  230, 278

Sunbird, White-bellied  230, 278

Swallow, Barn  212, 270

Swallow, Grey-rumped  270

Swallow, Lesser Striped  212, 270

Swallow, Mosque  270

Swallow, Pearl-breasted  270

Swallow, Red-breasted  212, 270

Swallow, White-throated  212, 270

Swallow, Wire-tailed  271

Swamphen, African (Purple)  94, 251

Swift, African Black  263

Swift, African Palm  263

Swift, Alpine  263

Swift, Common  263

Swift, Horus  263

Swift, Little  263

Swift, White-rumped  263

## T

Tchagra, Black-crowned  198, 280

Tchagra, Brown-crowned  280

Teal, Hottentot  237

Teal, Red-billed  60, 237

Tern, Whiskered  254

Tern, White-winged  254

Thick-knee, Spotted  124, 252

Thick-knee, Water  100, 252

Thrush, Groundscraper  206, 275

Thrush, Kurrichane  206, 275

Tinkerbird, Yellow-fronted  277

Tinkerbird, Yellow-rumped  278

Tit-Babbler, Chestnut-vented  275

Tit, Grey Penduline  278

Tit, Southern Black  278

Trogon, Narina  262

Turaco, Purple-crested  178, 257

Twinspot, Green  284

Twinspot, Pink-throated  284

##  V

Vulture, Cape  50, 250

Vulture, Egyptian  250

Vulture, Hooded  50, 250

Vulture, Lappet-faced  9, 50, 250

Vulture, Palm-nut  250

Vulture, White-backed  48, 250

Vulture, White-headed  50, 250

# W

Wagtail, African Pied  102, 271

Wagtail, Cape  102, 271

Wagtail, Mountain  271

Wagtail, Western Yellow  271

Warbler, African Reed  274

Warbler, Broad-tailed  274

Warbler, Dark-capped Yellow  274

Warbler, Garden  274

Warbler, Great Reed  274

Warbler, Icterine  274

Warbler, Lesser Swamp  274

Warbler, Little Rush  274

Warbler, Marsh  274

Warbler, Olive-tree  274

Warbler, River  274

Warbler, Sedge  274

Warbler, Stierling's Wren-  272

Warbler, Willow  272

Wattle-eye, Black-throated  277

Waxbill, Blue  218, 284

Waxbill, Common  218, 284

Waxbill, Orange-breasted  284

Waxbill, Violet-eared  218, 284

Weaver, African (Holub's) Golden  282

Weaver, Lesser Masked-  216, 282

Weaver, Red-billed Buffalo-  216, 282

Weaver, Red-headed  186, 282

Weaver, Southern Brown-throated  282

Weaver, Southern Masked  216

Weaver, Spectacled  186, 282

Weaver, Thick-billed  282

Weaver, Village  216, 282

Weaver, White-browed Sparrow-  282

Weaver, Yellow  282

Wheatear, Capped  275

White-eye, African Yellow  278

White-eye, Cape  182, 278

Whitethroat, Common  275

Whydah, Long-tailed Paradise-  285

Whydah, Pin-tailed  220, 285

Whydah, Shaft-tailed  220, 285

Widowbird, Fan-tailed  283

Widowbird, Red-collared  283

Widowbird, White-winged  214, 283

Wood-dove, Emerald-spotted  226

Wood-hoopoe, Green  152

Wood-Hoopoe, Green  266

Woodpecker, Bearded  268

Woodpecker, Bennett's  139, 144, 268

Woodpecker, Cardinal  144, 268

Woodpecker, Golden-tailed  144, 268

Copyright © 2023 by **HPH Publishing**
ISBN 978-1-77632-331-9
Text by Philip van den Berg
Photography by Philip and Ingrid van den Berg,
Heinrich van den Berg
Additional images by Phil Muller (p16, p31, p196), Charl Senekal (p173),
Ernest Robinson (p28), Tom van den Berg (p29), Isak Pretorius (p220),
Shutterstock (p8, p14, p25, p46, p63, p112, p113, p121, p164)
Thumbnail images by: Chris Cloete, Dawie de Wet, Duncan McKenzie,
Geoff McIlleron, Hugh Chittenden, Philip, Ingrid, Heinrich and Herman
van den Berg, Krista Oswald, John Carlyon, Johann Grobbelaar,
Lizet Grobbelaar, Anton Kruger, Phil Nel, Ernest Robinson,
Warwick Tarboton, Shutterstock
Publisher: Heinrich van den Berg
Edited by John Deane
Proofread by Margy Gibson
Design, typesetting and reproduction by
Heinrich van den Berg and Nicky Wenhold
Printed and bound in China
Third edition, first impression 2023
Published by **HPH Publishing**
50a Sixth Street, Linden, Johannesburg, South Africa
info@hphpublishing.co.za
www.hphpublishing.co.za